THE SANDY PUC' GUIDE TO

Children's Portrait Photography

SANDY PUC'

AMHERST MEDIA, INC. ■ BUFFALO, NY

Published by:
Amherst Media, Inc.
P.O. Box 586
Buffalo, N.Y. 14226
Fax: 716-874-4508
www.AmherstMedia.com

Publisher: Craig Alesse
Senior Editor/Production Manager: Michelle Perkins
Assistant Editor: Barbara A. Lynch-Johnt
Editorial Assistants: Carey Maines, John S. Loder

ISBN-13: 978-1-58428-234-1
Library of Congress Control Number: 2007942652
Printed in Korea.
10 9 8 7 6 5 4 3 2 1

Notice of Disclaimer: The information contained in this book is based on the author's experience and opinions. The author and publisher will not be held liable for the use or misuse of the information in this book.

Table of Contents

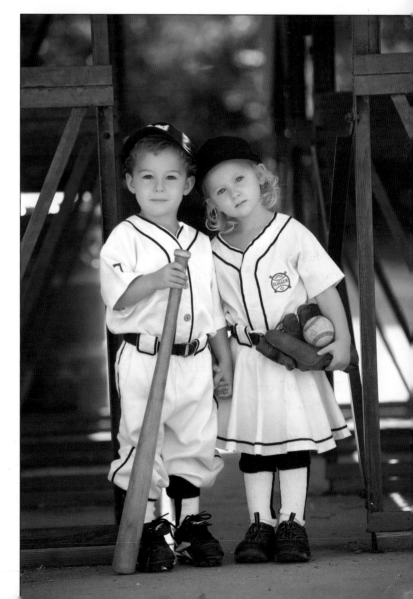

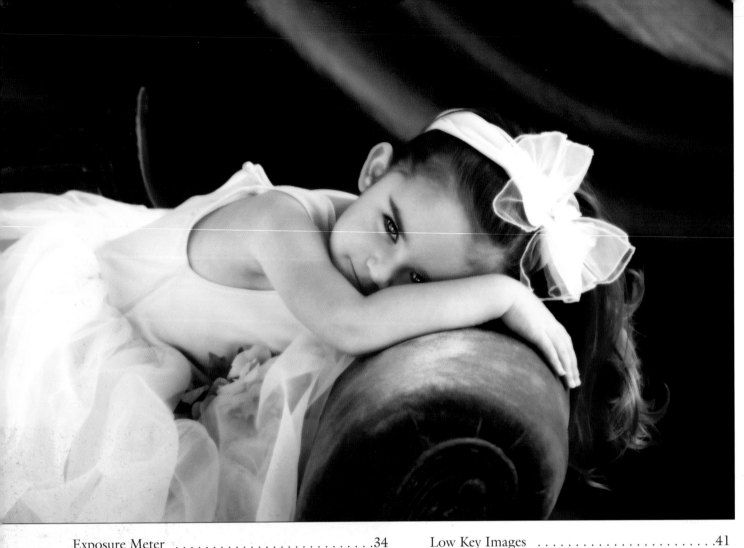

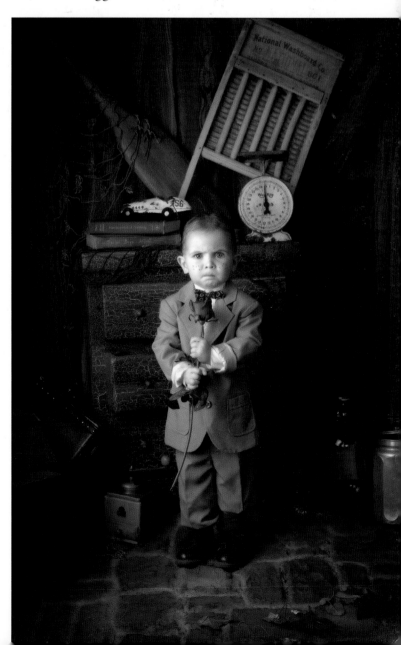

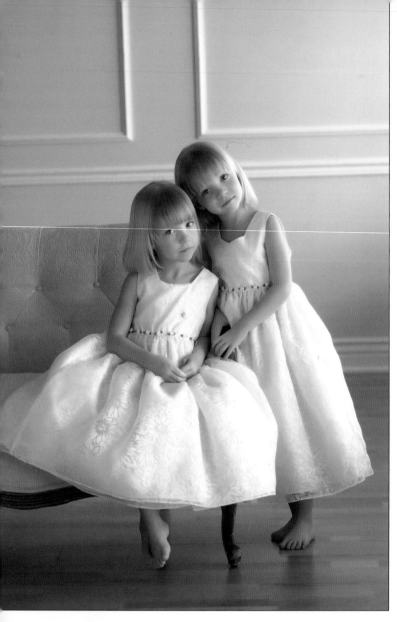

Acknowledgments

It is amazing to look back on my life and realize that being a photographer has been the only real job I have ever known (if you do not count a brief stint at Kentucky Fried Chicken). Photography has long been my life's passion. In the beginning, I was consumed by the desire to learn. Many of the photographic legends that were so inspirational during the beginning of my career are now some of my dearest friends.

Although I could never possibly acknowledge all of those who have played a part in my life-long transition, there were definitely a few special people who made a permanent impact on my life.

During one of the first photographic seminars I attended, I had the honor of watching photographer Lizbeth Gurrenia provide what I consider to be one of the most awe-inspiring moments of my life. Until that point, I had thought of photography as a skill, not an art form. It was Lizbeth's passion for true art that ignited a burning flame inside me. Her seminar moved me, and I could not help but desire to follow in her footsteps. From her insight, I knew that a caring portrait artist could immortalize special memories.

The second part of my growth has to be attributed to Ann Montieth, from whom I learned that reaching our full potential as photographers requires understanding the business side of photography in addition to the art. Her "business first" attitude became my motto and her insights inspired me to grow. Additionally, Ann inspired

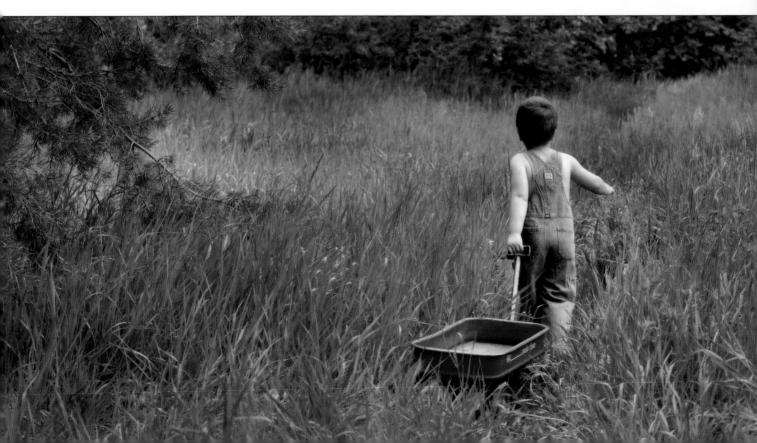

me to become a volunteer with the Professional Photographers of America. Like her, I wanted to share my time and talents with those who are just starting out. I have a great love for teaching and am thankful that I have found this outlet to show my gratitude to the profession and to the many teachers and mentors who have inspired me along the way.

My great friend and source of inspiration is Dave Junion. Dave single-handedly (and patiently) brought my studio out of the film age and into the world of digital capture. Dave's visionary disposition and never-say-die attitude also spurred me to take my work to a new extreme. The many philanthropic projects we have also worked on together proves to me that photography is not only an opportunity to capture moments; many times we are also the caretakers of someone's final memories.

I would be remiss if I didn't note that I am a product of how I was raised. My parents are the foundation of my world. In my mind, my mother was something of a superhero. She took care of her father's farm, raised five children with very distinct personalities, and took on many church responsibilities in addition to the daily tasks required to manage a household—I'm not sure how she actually did it all. My father taught me honesty and that a job was not done until it was done right, but one of the attributes I admire most is that my dad is always quick to forgive. He believes that people are inherently good and he always looks for those redeeming qualities in other people. I owe my parents so much for what I have become—and having children of my own now, I only hope that I can be half of the influence that my parents were to me.

Finally, it is important to note that I get far too much credit for the world that I live in. The truth is that from the beginning, I have surrounded myself with amazing people. First and foremost, my husband Edward and my children Katie, Alek, Nik, and Julz have been my greatest inspiration. Their trust, patience and love have determined all of my choices. Everything I am and hope to be is tied into the love that I feel for them.

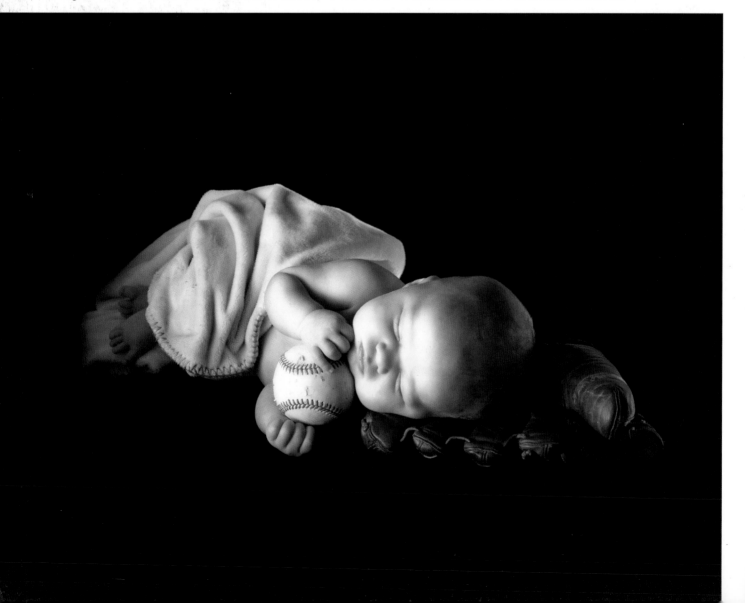

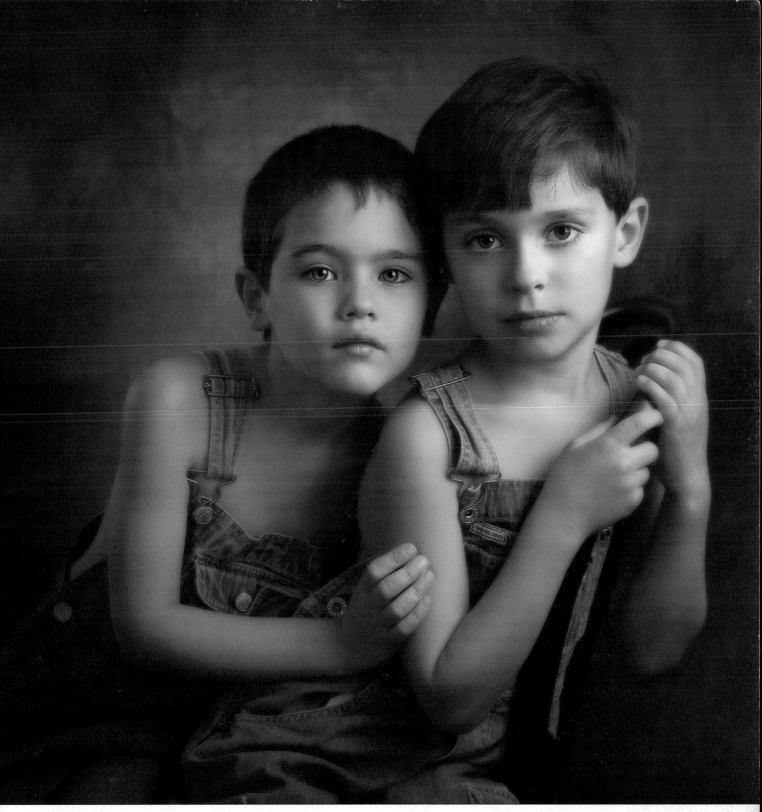

I have also been blessed to hire the most incredible staff that I could have ever hoped for. Don't get me wrong—not every person who has worked for me was a perfect fit. However, each person helped me learn more responsibility and how to become a better caretaker. Whether they were with my company for six months or six years, each person I have hired was, in one way or an-other, a part of my growth and ultimately the company's success. The energy that is created when happy people work toward the same goal is so powerful.

Introduction

I started my first photography business at the age of seventeen. As you can imagine, it was difficult to be taken seriously at such a young age. Fortunately, I never lacked the confidence and belief that if I really wanted it, it could be done. Every year I would study and learn everything I could to master my skills. Although I never had formal training, the school of hard knocks and Real Life 101 provided me plenty of opportunity to grow.

I always had a vision of what the perfect studio would be like, and each year my studio has grown—as have my

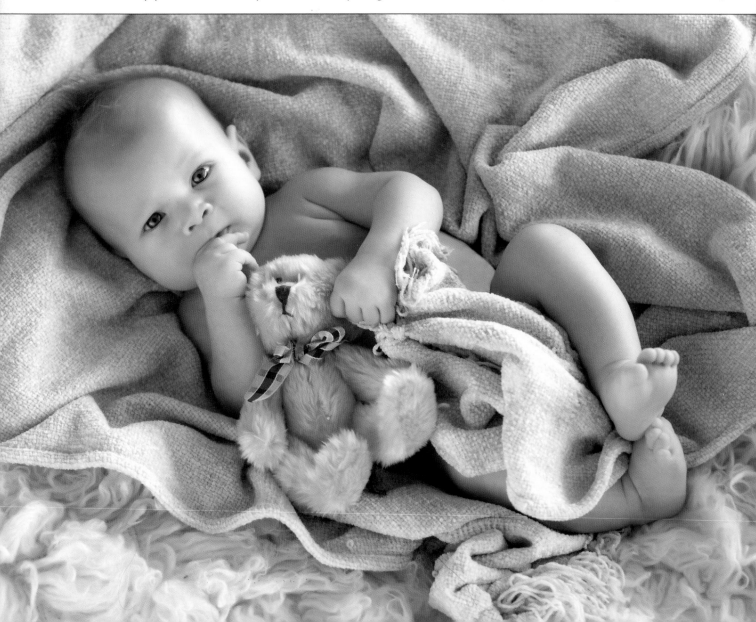

dreams for it. It is amazing to think that my entire studio was once located in my master bedroom and I was the only employee. If I needed to photograph a family of more than five people, I had to back up into the bathroom and stand in a sink to do so. From that humble beginning, I moved into my first 2,000 square foot studio. I soon outgrew that space and then added another 3,000 square feet. Now, only nine years later, we (myself and seventeen amazing employees) are building our dream studio. This building is the fruit of many years of wishing and planning. All of this has come from hard work and team effort.

At this point in my career, photography is not just my means of living, it is the way I connect with the world. I feel that we, as photographic artists, must be committed to the responsibility of capturing and preserving the legacy of children, families, and every individual who crosses our path. My business is so much more than a nine-to-five job. It is a manifestation of who I am. I treasure every day I am able to provide this service. I know I have been a part of so many important moments. I can only imagine what joy the coming years will bring.

That said, I would love to tell you that every day I work in my dream job perfect little angels arrive at my door, all clean and ready to participate in the fun—but that is far from reality. In truth, most of my sessions are fast and crazy (and a lot of fun). In the final set of thirty to sixty images that the client will see, there will be one or two breathtaking images, a few really good images, and a lot of average ones.

About once a month, though, the perfect child with the perfect hair and outfit will arrive. This session is what I call a dream session. When the client's preparations combine with great lighting and background selections, the stage is set for creating powerful images. The work you see in this book is a collection of many of those perfect days. I don't want to mislead you by not admitting that.

While you won't always be able to solve every problem you encounter (ultimately the child's disposition truly decides how far you can go), this book presents the tools

you need to overcome the vast majority of issues you'll encounter when photographing children. From attracting and impressing prospective clients, to creating memorable images of their children, to selecting the products and sales techniques that will boost your bottom line, this book is designed as a road map to guide you on your personal path to success.

Get the Entrepreneurial Spirit

As long as I can remember, I have been an entrepreneur. Growing up in the small farming community of Orem, UT, gave me many opportunities to become a small businessperson.

Some of my earliest memories are of climbing trees at 5:00AM to pick cherries. There was something magical about starting the day sitting up high in a tree. As the sun rose, birds would begin to chirp and crisp air would fill my lungs. When the cooler hours passed, the air would warm and off would go my jacket. The sun would start to heat things up, and slowly life would begin to appear. In the distance, I would hear my cousins in other trees laughing, joking, and playing around. As we worked the day away, I knew that my efforts had purpose. At 10 cents a pound, I was well on my way to a few dollars to spend by the end of the day. Having those dollars would open the whole world (or my small one) to so many choices. After a day's hard work, we would cash in our lugs and head off to what we considered summer paradise. If we did well, it was a two-mile walk to the public pool. We would spend the end of the day splashing, enjoying the sun, and eating ice cream until the sun set. On days that we were less ambitious, we might walk to Taco Bell for a 95-cent meal and then hop in the irrigation ditches and float our way home.

Financial freedom came early, and the lessons I learned from that independence stayed with me for the rest of my life. Whether I was staying up all night catching night crawlers to sell to the local fisherman, or loading up my wagon and selling fresh gladiolas door to door, I knew

that staying focused on a plan and working hard was the only way to get a few of the extra benefits that a small town could offer.

"Life is either a daring adventure or nothing at all."—*Helen Keller*

Don't Be Afraid to Make Mistakes
In addition to the spirit of entrepreneurship, my life has also taught me the importance of three basic philosophical principles: love unconditionally; treat others with respect; and give back to the universe. Of course, while I try hard to live by these principles, I have failed at many of

them throughout my life. I do not claim to be someone who is nearing perfection—quite the contrary. In fact, I feel that each day my path becomes clearer because my choices, bad or good, affect my entire surroundings.

Whatever philosophies guide your journey, I urge you to consider that your mistakes just might be the keys to your success. I would like to tell you that my path was easy—that all I had to do was imagine success and it happened . . . but that would be far from the truth. To get where I am now, I basically made every mistake in the book—in rapid succession. From each mistake, however, I learned an important lesson. From these moments, my current studio was built. By considering your mistakes

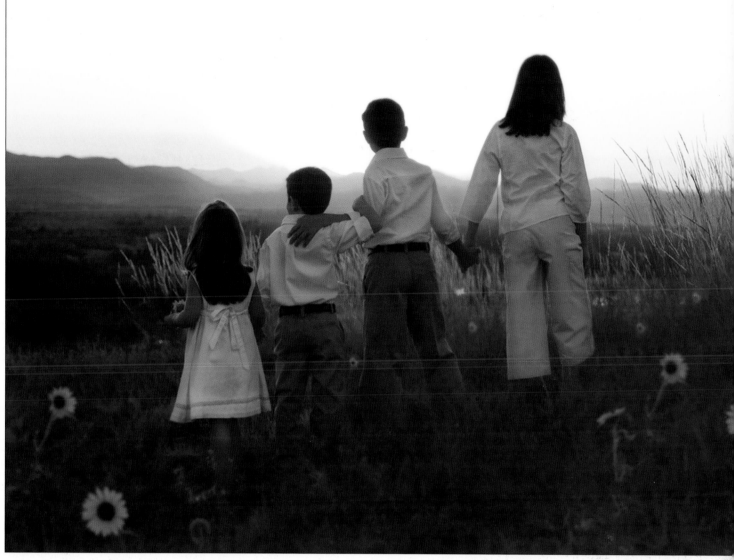

and creating a system to avoid similar problems in the future, you will find yourself better equipped to grow and to overcome the challenges that face businesses today.

Spend Your Time Wisely

I remember the days when the job was done the minute you dropped that roll of film in the lab bag. Today, however, photographing the images is only the first step in the artistic process. While this results in higher-quality images and fantastic artwork that generates more excitement and higher sales, we sacrifice so much time to create these unique products. There is always one more thing you can do to make an image better. However, the opportunities to enjoy all the other things in life, like family dinners, days at the park, or spending time with those you love, are fleeting. Like many photographers, one of my biggest daily struggles is leaving work behind.

My dear friend Jeff Lubin gave me one of the most important tidbits of advice I have ever received. Many years ago, I was searching for a photographer to speak at a conference that I was chairing, and Jeff's name was mentioned as a possibility. Having never met him before, I contacted him on the phone and asked if he would be interested in speaking.

As we chatted, he described his studio and its complexities, and I mentioned that our studios sounded very similar. He said to me, "I bet there is one thing that is very different about our studios." I asked him what that might be, and he told me he never works on Saturdays. I was surprised because, in my mind, Saturdays were a very big day. I explained to him that they were an important part of my income, and I felt I just had to work Saturdays.

At that point, he told me a personal story about his son. At the age of fourteen, Jeff's son had battled a dif-

ficult and exhausting round of cancer. Jeff explained that one of his greatest accomplishments in life was that he had never missed a Saturday game or activity that his son had. Because he had always reserved Saturdays for his family, he knew that he had no regrets. I was moved to tears. Jeff, a complete stranger, urged me to commit to no longer working Saturdays as well. As tears flowed down my face, he stayed on the phone and had me take a permanent marker and cross out every remaining Saturday that year.

What an amazing gift he gave me that day. I have since enjoyed so many great moments in life because Jeff took the time to reach out and share a little bit of wisdom with me. The funny thing is, not working Saturdays has really made no difference in my business or financial success.

Currently, I personally average six to eight sessions a day, four days a week. In addition, I have six other photographers at different levels of training, three of whom can provide sessions at my level. On an average day, twelve to eighteen sessions are conducted at Expressions Photography. (*Note:* In addition to the volume of sessions we shoot, our work is priced well above our local competition. To create this volume at those prices, a good balance between marketing and excellent customer service is a must. This will be covered in greater detail later in the book.)

Look for Ways to Evolve

After seventeen years of learning and studying, I am astounded at how much my style has changed. At the beginning of my photography career, I would look at books and magazines and be blown away at the artistry and style

"If I have **seen farther** than others, it is because I have stood on the shoulders of giants." –*Sir Isaac Newton*

that graced the pages. I could not even begin to imagine that my work would ever reach those amazing heights. As more time passed and my skill improved, I would look

back at those books and see that my work was now closer and more comparable to the pages I viewed.

One of the greatest benefits about this wonderful profession is that there are no set standards or rules that dictate how a finished image should look. It is the artist's discretion to decide what the final outcome will be. There is also a generous amount of room for growth and change. Being an artist has taught me that in life and in art, there is never a final destination. It truly is the journey that makes the trip worthwhile.

Embracing these changes and looking for ways to continue to grow is part of making your way in this business—and in life. So, no matter where you are on your path, take the time to look back at the stepping stones you have passed along the way and at the ones that lay ahead. Take every opportunity to learn and grow, knowing that it will only enhance your ability to create and

"**What you do today** is important because you are exchanging a day of your life for it." –*Author Unknown*

capture memories that will last a lifetime.

2. A Complete "Kid Care" System

In our studio, 67 percent of our work is with children under the age of seven. The next 22 percent is comprised of family work—largely the families of the children that make up that 67 percent of our subjects. In other words, over 89 percent of what we do each year will include children under the age of seven. Knowing that, we must prepare the studio to handle these little ones. From the moment a child walks in the door, we must ensure that their experience will be fun. From a warm and friendly receptionist to the many toys and tricks we use in the studio, we strive to create a complete "Kid Care" system. Of course, we can't forget the parents, either; many of the amenities we offer are designed to make coming to the studio a welcome experience for them, too.

First Impressions Count

When a new client comes into your studio, they need to experience a "wow" factor. My current studio (we are in

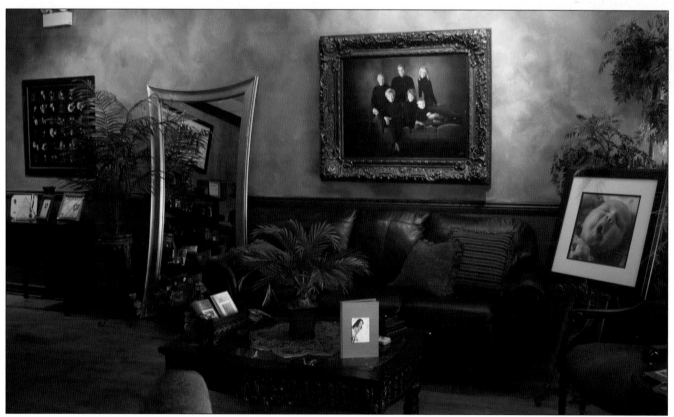

Regardless of your location, it is so important to remember that you only get one chance to make a good first impression.

It is important to have an area or an alcove just for children in your studio.

the process of building a new one) is not in an incredible location. It is on the tail end of a strip mall, and from the outside, it definitely does not look impressive at all. As a result, there are probably some clients who have considered leaving before they come inside. The minute they walk through the door, however, we put all our efforts into creating a great first impression—they are immediately transported from a ho-hum strip mall to an upscale studio. Suddenly they are looking at gallery walls, living-room furniture, and plush amenities. We have created a cozy and comfortable atmosphere that makes any guest feel at home.

Clean and Organized. Imagine that you are your client. As you step through the studio door, what do you see? What does the studio smell like? Is there a refreshing candle scent or the fragrance of fresh-baked cookies? Or do you smell leftover tuna salad sitting in the bottom of a trash can? What does the room look like? What type of furniture do you have? Is your lobby designed to draw clients in with beautiful furniture and interesting artwork? Is it clean? When a child crawls on your floor, should Mom be worried? Every space your clients see, all the way to the bathroom, needs to be pictured in your mind. Is there any area visible that would embarrass you? Even spaces where your clients don't usually go need to be clean, because sooner or later a client will see

them and judge you. Every area should have a professional and polished feel to it.

If you are working out of your home, the same rules apply—keep everything tidy and in its place. For the first eleven years of my career I had residential galleries with studios, at my various residences, set up in basements, kitchens, and even my master bedroom. With the added chaos of children, laundry, and life, keeping a professional environment in the home can be very difficult. I found that by creating and implementing a to-do list before clients arrived for their scheduled appointments made the process much easier. About fifteen minutes before the appointment, I would go down this list and verify that everything was done. This included, a room "tidy" check, lighting candles or baking (pre-made) frozen cookies to fill the house with a yummy smell, and even washing my own children's faces. This list was key in assuring that I did not miss anything that might cause me embarrassment.

A Place for Kids. It is also important to have an area or an alcove just for children in your studio. This play area should contain nice toys that won't pose a danger to small children. The toys should also be maintained and cleaned regularly. There is nothing worse than seeing your child put a toy covered with grime and fingerprints

"Other things may change us,
but **we start and end** with family."
—Anthony Brandt

in his mouth. Your range of toys needs to be things that a one-year-old would like and that a seven-year-old could find some entertainment value in. Video and interactive games are great for keeping older children busy.

Regardless of your location, it is so important to remember that you only get one chance to make a good first impression. If you give it your all, your reward will be evident in the final sale.

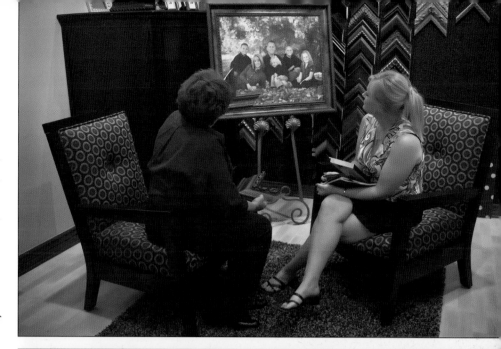

The First Phone Call

The client/studio relationship usually begins with a telephone call. You or your staff must quickly communicate to the client that you run a child-friendly studio. The client needs to understand that you know what you are doing and capable of handling children.

During the initial contact, the person fielding the call should have a list of questions they can use to prompt the client to determine the type of portrait they desire. They need to hone in on the age and sex of the children and ask questions such as, "What do your children enjoy doing? Are you interested in an indoor or outdoor session?"

When speaking to new clients on the phone, make an effort to get them excited about the experience. Talk about clothing choices, locations, and props. Every age group has a certain style or type of portrait that is most appropriate to it. Be prepared and know what is suitable for the age of the child(ren) in question so that you do not go off on tangents and confuse your prospective client. Many clients also have unique requests or children with special needs.

Ultimately, before the phone is put down, the new client should be totally confident that you will provide the experience they desire. Most importantly, smile when you answer the phone—it will put a smile in your voice.

Consultations

New Clients. The ideal way to prepare for a session with new clients is with a pre-session consultation. At our studio, the receptionist (who is trained as a por-

No matter how friendly the child may be, avoid paying too much attention to him before the shoot—save those smiles for the session.

trait consultant) usually does this, although some of the photographers also choose to schedule appointments for consultations as well. In a special room dedicated to these consultations, we make the client comfortable by offering them refreshments, then show them an image presentation that features images taken in a location similar to the one they are interested in or in style for which they have expressed a preference. The image consultant also helps the client make a decision as to whether they want an indoor session or an outdoor session, what type of clothing is best for the location they choose, whether or not the child needs to wear shoes, and what type of accessories they should bring. We also provide a lot of clothing and accessories at our studio and we want the client to be aware of that option.

We also take the time to discuss pricing, framing, and the client's final portrait needs. We definitely want our clients to be educated on the many products we have to

offer and what they might invest. After all, it is far better for a client to decide that they can't afford us at this thirty-minute presentation than after a full-hour portrait session and a ninety-minute sales session. Not only do we save time in the long run, we eliminate the disappointment and frustration a client may feel if they have had a wonderful session but cannot afford the images they want.

If a client cannot make a pre-session appointment, we rely on our receptionist to explain the process via the phone, educating the client on what we have available, giving them suggestions on wardrobe options, and clarifying our pricing structure.

Past Clients. For returning clients, we have a computer station where they can can sit down and go through a web browser to further make their location choices. With this technology, they can view sample images from the specific locations they're interested in, look at cloth-

ing appropriate for that area, and select props. They can even print out directions to our location settings.

When the Client Arrives

When a client arrives for their session, it is our receptionist's job is to pamper the parents, bringing them refreshments and making their brief wait pleasant. As noted previously, we also have a nice play area for children to wait. Providing this distraction assures that when the child makes her way back to the camera room she has not been bored in the waiting area. The playroom also allows Mom a few moments to rest. It is stressful to plan, prepare, and deliver her children to the studio. Make her comfortable, offer her a drink, and compliment her efforts in preparing the children. Giving her a few pampered minutes will eliminate some of that stress, helping to ensure that it does not make it into the camera room.

Additionally, my employees have been trained not to engage or interact with children when they first come into the studio—no matter how adorable and friendly the kids may be. One of the worst things that can happen for a session is when a client arrives fifteen minutes early and a staff member pays too much attention to the child. By the time the child comes into the studio, she is overstimulated and tired. When a Mom says, "Oh, she was so cute in the lobby—she was smiling at everyone," I know this rule has been broken. Children have short attention spans and limited abilities to handle a lot of interaction. If they use all their energy and smiles in the lobby, there won't be anything left for the session.

After a client arrives and settles in for a few minutes, we provide them with a personal space to unload their possessions. This includes a bar for hanging clothes, a shelf for keys and Mom's purse or diaper bag, and a small sheepskin rug with a clean blanket that can be used to change and dress the baby. The studio is always cleaned, organized, and vacuumed after every session, so this space is attractive and ready to use.

Your Preparations for the Session

Morning Preparations. In the morning, you should begin by preparing your studio. White balance your camera so your color will be correct and make sure your area is tidy and organized. You should be able to turn left or right and know exactly what's going to be there. You should know exactly where to find each chair or prop you might need. This organization is necessary to establish a

Providing a play area helps prevent pre-shoot boredom and leads to a better session.

If the child is shy and clings to Mom, I know I need to take it slowly.

We're professionals, and we need to preserve a dignified atmosphere in the studio. (*Note:* There is a difference between being passionate and being disorganized. Be sure you are in the "creative" mode and not the "I can't find it" mode.)

At the start of the day, it's also a good idea to check your schedule and mentally prepare for your individual clients' needs, planning out props and image ideas. For example, if I have a session with a three-month-old, I will pull out a specific prop, like the baby bassinet. If it's a six-year-old, however, I will be thinking of something totally different.

Attitude is Everything. A great session starts with your own frame of mind. When you walk into the camera room, try to put everything behind you. It's good to have a door that closes so the hustle and bustle outside isn't a distraction. You don't need to hear clients talking or children running down the halls. You need to have a clear focus.

Try to check any negative feelings at the door. Enter with as positive and energized a mindset as possible. If you do not feel up to a session, whether you are ill, frustrated, or just tired from the night before, the images won't be as successful as they could be. I feel it is important to make a commitment to my clients to be 100 percent ready and willing to fully commit. When I am not giving the client my best, I am always dissatisfied with the results. I feel I cheat my clients when I do not try my best to overcome any personal issues.

Another distraction that can affect your attitude can be working with a client you do not enjoy. These people, fortunately far and few between, are individuals with very distinct issues that are difficult to overcome. Whether

comfort level in the studio—without it, you'll spend the session running around like crazy trying to find things every time an idea pops into your head (like a little girls shows up in a pink dress and you decide you'd like to photographer her on a pink background). This type of behavior detracts from the calm you want to maintain.

they direct the whole session, constantly tell you what to do, or hurt their children to make them obey, they can make it hard for you to focus on your task. Invariably, the session will be compromised by their behavior. It is only with a positive attitude that you can be effective at your job when working with these most difficult clients.

Interacting with the Client. Time flies by quickly on an average day at our studio. When a client arrives for a session, I am usually at my desk editing previous jobs. Still, I make it a point to start all my sessions on time, so I immediately go to the waiting area and greet them. If they are new, a handshake is appropriate; for old friends, the greeting may include a hug.

As the client prepares her personal area (see page 23), I discuss my thoughts about how I think the session should go. I talk about background choices and concepts, and I listen to her thoughts to ensure that I understand her vision for the session. As she prepares, I turn on all of the studio lights and prepare the background.

All the while, I am watching the child's reactions to what I do. So much of how the session will go is determined at this point. If the child is shy and clings to Mom, I know I need to take it slowly. If he is moving about and looking at things, I can talk to him and warm him up. If he is very busy—running, touching everything, or being silly—I know that I should not do anything too silly; otherwise I will not be able to contain his energy during the session.

Once I am ready, I talk to the child for a few minutes. This helps me determine exactly what the child might be

As you talk to Mom, watch the child's reactions and determine how to proceed with the session.

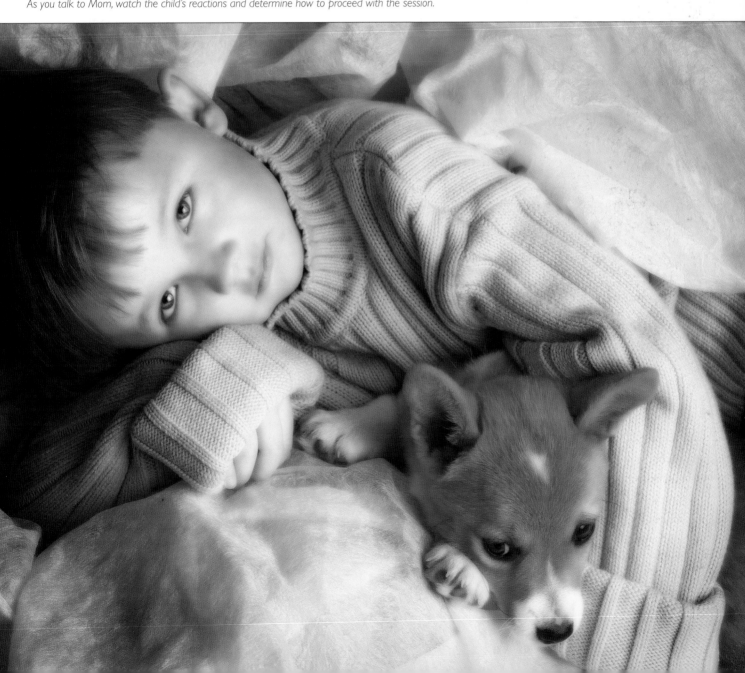

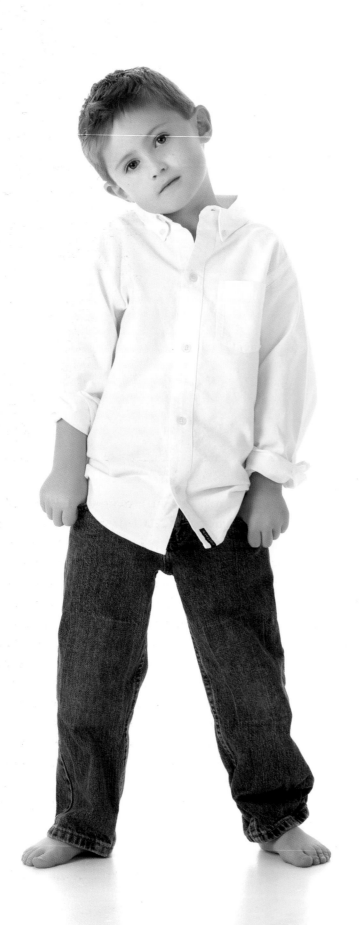

ABOVE AND FACING PAGE—*Even a simple portrait requires getting the child comfortable in a complex environment.*

like. To do this effectively, I get down on their level and look at them eye to eye. I read their body language and consider what they might be feeling. I do everything in baby steps because I know if I take a little time in the beginning, the middle and the end of the session will be much better. After so many years of creating relationships with these children, it is completely natural for many children to come into the studio, sit down, and do anything I ask of them. Unfortunately, it does not always start out this way. It takes a little time and a lot of caring to establish that relationship.

The Camera Room

I am sure that from a small child's perspective, the studio can be an intimidating place. Therefore, I am very careful to have the main lights on when a child enters the room. As I start to set up, I always share what I am doing. I also warn them when I am going to turn off the lights or use the roller system, because it can be loud. Most children are fine coming into the studio for the first time. If a child seems nervous or shy, I take a few extra minutes to explain what things are and how they work.

Naturally, your studio must be kid friendly—and that means safety first! Anything that could drop, tip over, or otherwise cause harm should be secured. If something has a potential risk, it should be explained to Mom before entering the studio. We also intentionally keep several items low enough for a four-year-old to see. Our treat box is located at what I call the five-year-old mark. This giant transparent box of goodies is low enough for all children to see into but high enough that only children four years and up can reach in. It is safe to assume that when a child is four to five years old, they will get excited about the candy but usually won't help themselves without permission.

3. Camera and Lighting Equipment

For my first thirteen years in photography I only used film. Back then the average session would include two rolls of film with fifteen shots per roll. That meant that out of thirty shots, at least fifteen of them would need to be near perfect—and this was in a time before head swaps. Scary isn't it? At that time, my creative tools were simple, I used an on-camera vignette and a Don Blair #2 softening filter. When a session was completed, the film was sent to the lab. When it came back it was ready to be seen by the client.

If you have attended a photographic trade show in the last few years, you understand that purchasing equipment

Whatever equipment you choose, understanding how to use it is critical for creating memorable images.

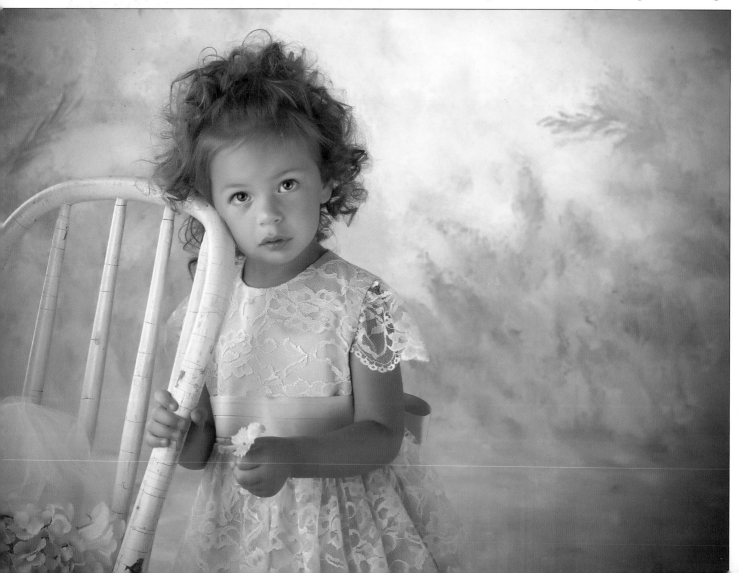

is no longer an easy game. There are hundreds of cameras, tripods, camera bags, and other items available to choose from. In addition to these products, you need to choose a computer, monitor, graphics tablet, and many other digital tools—devices now standard in the creation of beautiful finished portraits. When all is said and done, though, the type or brand of tools you use is not as important as understanding your equipment and how it works.

Camera

When I started using digital capture, the Fuji S1 was an incredible option, but it was a difficult camera to use because of its limited exposure range. In the first four years of shooting digitally, I went through six different camera models looking for the right one. Although I invested over $75,000 looking for the perfect device, one that would truly compete with film, it was important for me to use the best camera available at the time to provide great wall portraits for my clients.

Shooting to a Computer (Or Not). In the past, I also shot directly into a computer. This was useful for controlling exposure, adjusting lighting, and ensuring proper cropping, because I could instantly see the results on a 15-inch screen. This also aided me in establishing a good relationship with my clients, because I was looking at them and directing them simultaneously, rather than focusing on the back of the LCD screen. At this point, I am no longer tethered to a computer. I have learned to control the elements and trust my instincts, so I prefer the freedom to move around freely. I am careful not to pay too much attention to the LCD, though, as this disturbs the relationship I want to create with my client.

Stay Up to Date. Gone are the days when you selected a camera and stuck with it for your entire career. If you're still trying to do that, you're failing yourself and your clients. With digital capture your choices are limitless. And as technology improves, it is necessary to upgrade your equipment to keep up with the changes.

It would be impossible for me to make any recommendations about which camera to buy; as soon as I did, something new and improved would be available. Currently, I use all 35mm Canon professional gear, and I have no intention of changing anytime soon. I love the consistency and control that these cameras supply, as well

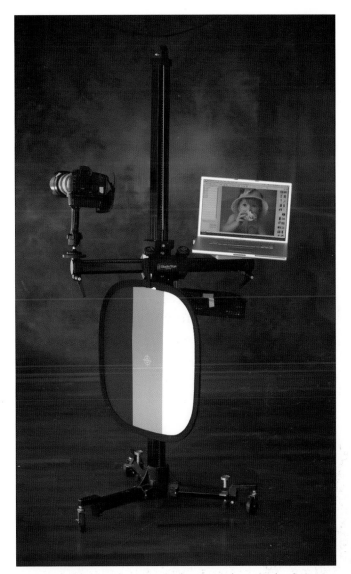

Shooting directly to a computer provides some advantages but limits your ability to move around freely.

as the support and educational opportunities that Canon provides to its customers. Just take a look at their web site, and you will see that their number-one quest is image quality. It is also refreshing to know that digital capture no longer requires a second mortgage. For a few thousand dollars you can purchase a camera that will last for several years.

Get Good Advice. There are two things you must do when you make your decision to purchase a camera. First, you need to research your options and ask the right questions. I always hesitate to ask a camera-store employee these important questions—after all, you do not know how knowledgeable they actually are or what their motivations might be for selling you a specific product. They may have been given an incentive to sell a particular

In outdoor portraits, fast shutter speeds are critical for freezing motion, such as blowing hair.

brand and therefore inclined to recommend it above all others. The best way to really know what camera to use is to talk to other photographers who are producing work you admire. Like me, many of these photographers have invested large amounts of money in image-capture devices, and they will generally be very honest about what they have learned. You can also look in trade publications and magazines.

Look for Top Quality. Finally, you should understand that your camera is only a tool. It cannot evoke expressions or design the artistic elements in the final image. However, this tool is very important when it comes to the final image presentation. It doesn't matter how good your work is if you cannot provide your client with a final product that has excellent shadow and high-light transitions, clarity, and clean focus. Without these important attributes, any investment in capture technology is a waste. I believe it is better to purchase a high-quality capture device than to invest in more props or new backgrounds.

In reality, I know that very few clients will purchase the 60-inch (or larger) portraits my cameras are capable of producing—but we do sell a few of them every year, I will do everything I can to ensure that I can produce the best portraiture possible. Doing so also guarantees that the hundreds of 24x30-inch and smaller wall portraits our clients invest in will be of superb quality, too.

Camera Settings. Regardless of your camera choice there are a few basic camera functions that have withstood the digital revolution. These functions are critical

to understanding how to control light and capture your desired image.

The shutter speed determines how long your shutter remains open while light passes through to expose your image. In children's portrait photography, shutter speeds are generally used to stop motion. If you have a child on swing, for example, you can use a higher shutter speed of at least 1/250 second. This will stop time and capture the moment. Using a faster shutter speed can also control lighting. If a background is very bright, your shutter may be moved to 1/250 second or higher to capture the detail. (*Note:* If you choose to do this, you must make sure your subject has enough light for a proper exposure.)

The aperture controls the amount of light that will be allowed to reach your image during the time the shutter is open. The wider the aperture, the more light you are letting in. Aperture settings are noted in terms of f-stops, which have an inverse relationship with the actual size of the aperture. For example, if your camera is set to f/8

and you move it to f/5.6, you are actually increasing the aperture opening and admitting twice the light that f/8 was producing.

Using a wide aperture produces a narrow depth of field; using a narrow aperture produces a wide depth of field. Depth of field is the amount of visible focus in front of and behind the subject. If you have a scene that has a lot of important detail, you may want to use an aperture of f/11 or higher for a large depth of field. If the scene is very distracting, you may choose to work with an aperture of f/2.8 to blur the details. Wider apertures may also be called for when working in low-light situations, where allowing more light to enter the camera can enable to you a shorter shutter speed to freeze action.

Carefully controlling these variables is critical to good exposure. It is also especially important when working with multiple children. With such groups, you should work with a shutter speed that is no less that 1/60 second, simply to compensate for subject movement. Also, en-

When it choosing an aperture setting for working with multiple children, I never shoot an f-stop number lower than the number of subjects I am working with. This ensures adequate depth of field.

Some portrait situations (left) call for a high ISO setting, others (right) require a lower one.

suring that the depth of field includes all of the subjects requires a smaller aperture. When it comes to determining what aperture to select while working with multiple children, I have a simple rule. I never shoot an f-stop number lower than the number of subjects I am working with. For example, if I were photographing three children, I would use a minimum setting of f/4. If there were eight children, I would use a minimum setting of f/11. (*Note:* Remember, though, that many other variables can affect your choices of aperture and shutter speed, such as the quantity of light or movement of the subjects.)

Another important setting is the ISO, the rating used to determine the camera's sensitivity to light. The higher the number, the more sensitive the capture device will be to light. When selecting the ISO you must understand what you are looking for. For instance, if you are creating an image on a sunny beach with a bright-blue sky, setting your camera's ISO to 100 would be appropriate. However, if you are in a low-light situation, you may need to push the ISO to 400 or higher.

Lens Selection

When it comes to lens selection, these days the sky is the limit. Lenses now are becoming not only faster (with apertures as wide as f/1.8), but they are also being effectively modified to control weight and vibrations. Selecting the proper lens is one of the most important decisions you will make, as it will ultimately determine your range of focus and the distance you will be from your subject.

Normal Lenses. A normal focal-length lens (around 50mm on a 35mm camera) creates an impression similar to that produced by human vision. One advantage of normal lenses over the shorter or longer ones is that they are generally faster (offering larger maximum apertures). The disadvantage of using this lens for portraiture is that the perspective is very much like what your eye sees, making it more difficult to create dynamic images.

Telephoto Lenses. A long focal-length lens provides greater image magnification and a narrower angle of view than a normal lens. One of the advantages of this lens is

that there can be more control over the desired depth of field, making your subject more dominant in the image. The disadvantage is that a longer lens requires a greater working distance between the subject and the photographer. This can make it very difficult to maintain a relationship. Additionally, these lenses can be very heavy; they usually require a sturdy tripod for support, especially when working with young children.

Specialty Lenses. There are many specialty lenses available on the market today. Some of theses lenses include the fisheye, macro, and Lens Baby. Each of these creates a certain amount of distortion within the image. Knowing this, photographers can use them to their advantage and create whimsical images that add personality to the client's final product.

My Choice. My preferred lens is generally the 70–200mm f/2.8 zoom. One of the frustrations I found when I switched to digital was the lack of control when it came to compressing the background. The 70–200mm finally gave me back this control—I can blur out the background and make the subject pop off the page. Because the weight of the lens is a concern, I have also invested in the Canon 70–200mm f/4.5, which is a bit

From full-length portraits to tiny baby features, you need a variety of lenses to make the most of each shot.

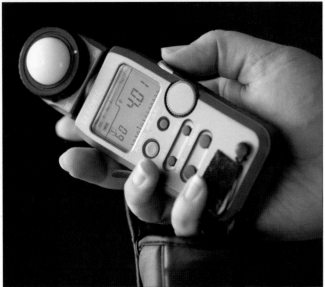

Don't just "eyeball it." Get a good exposure meter and learn how to use it.

the fisheye for funny, whimsical shots, and a 100mm macro lens for extreme close-ups and for capturing tiny baby features.

Exposure Meter

Exposure meters operate on the assumption that most scenes consist of a variety of tones (from very dark to very light) that average out to a medium gray tone. The meter measures the scene, then calculates an exposure that will produce this overall level of brightness in the final photograph. To me, using a light meter is invaluable in determining proper exposure. Unfortunately, many photographers today use what they call "eyeballing." They look at the LCD and say, "That looks pretty good." To me, metering this way is not an option. I believe what you see is not always what you get. Photographers need to get out of the mindset that they can make an adjustment later to fix exposure errors. It is best to do it right

slower but weighs half as much as its big brother. Both are important tools in the work I create. Some of the other favorites that I use are an 85mm portrait lens for creating really elegant portraits and a relatively new lens on the market called a Lens Baby. I also enjoy using both

the first time. This will make you a better artist and will ultimately save you time.

Tripod

Another wise purchase is a good, sturdy tripod. When you first use this piece of equipment, you may find it cumbersome and difficult to work with. Trust me, though—once you master the techniques, you will find this is one tool you cannot live without when it comes to working with children. A good tripod lets you keep your full attention on the child and move freely to engage your

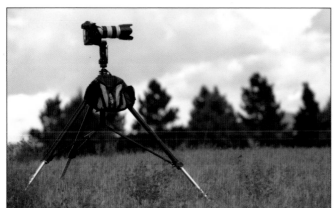

subject with tricks and ticklers. When you purchase a tripod, consider its weight, ease of use, and the controls available for adjusting the camera's position. My preference for years has been the Bogen brand. Although it is a bit heavy, the ease of use when moving from low angles to high angles makes it all worth it. For the camera mount, I prefer the pistol grip over a pan head for its speed and control.

Lighting Equipment

Color Balance. When I made the transition to digital, I quickly learned about the relationship between the color temperature of the light source and the color in the final image. First and foremost, if you are using any softbox or light modifier that has fabric attached, the color of the fabric can adversely affect your final image. If your softbox is old and yellow, then your images will have yellow cast. Knowing this, you can eliminate hours of post-production color correction simply by investing in new equipment. It is also important to not mix different

A good sturdy tripod is especially critical for shooting outdoors.

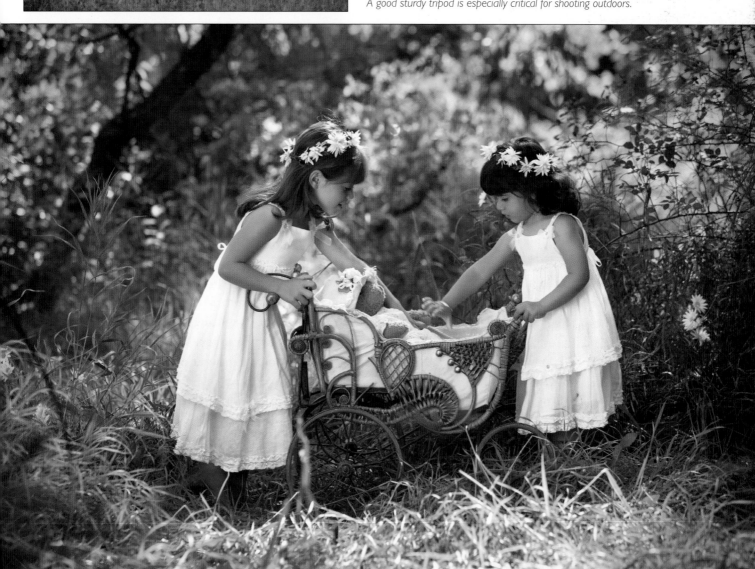

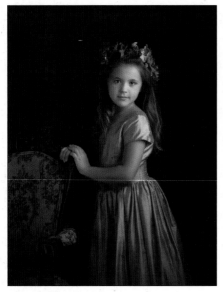 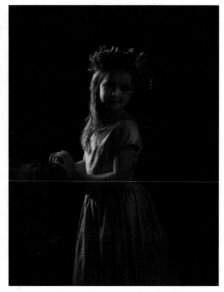 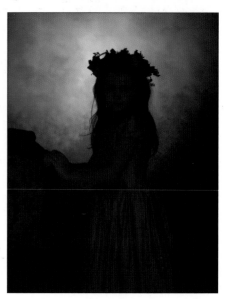

ABOVE AND FACING PAGE—*From left to right (above) the effect of the individual lights in this setup—the main light, accent light, and background light. On the facing page is the portrait with all of the lights in use.*

brands of equipment, as they each have their own color temperatures and can cause an imbalance when used together. (*Note:* The color of the surrounding environment has an effect on the final output as well; any color it reflects will show on your final portrait.)

Our studio's choice for controlling these elements in the studio is Photogenic lights and Larson softboxes. These tools have provided us with consistent color temperatures for many years. Most of my studio work is created using a combination of the 3x4-foot softbox and several 10x36-inch kickers (with egg-crate light modifiers) as accent lights. Our high-key area is lit with a 52-inch starfish that has custom flaps attached for controlling lighting direction.

Main Light. The main light (or key light) is the brightest light source in a photograph. It illuminates the planes of the face and controls the direction of the shadows. Although there are many options, such as umbrellas and parabolics, I use the 3x4-foot Larson softbox for most of my studio work. This softbox is the perfect size, because it mimics the light that an average-size window would produce. The light from it is soft and excellent for most work. I also really love the catchlights it creates in the subject's eyes.

Fill Light. The fill light is a supplemental light source. It is less intense that the main light and used to lighten shadow areas without casting secondary shadows. When working with an individual subject I rarely use a fill light—but the more subjects there are within the frame, the more likely I am to use a fill light to balance out the shadows and ensure a proper exposure.

Kicker or Accent Light. A kicker (or accent light) is a small light source used to illuminate a specific area or feature in a shot. It can be used to bring out the edge of a subject, such as the hair or shoulder, and create more separation between the subject and the background. My favorite source is the 52-inch Larson strip light, which

"Far and away the best prize that life offers is the chance to work hard at work worth doing." *–Theodore Roosevelt*

helps me define my subject and bring the viewer's eyes exactly where I want them. (*Note:* Although the Larson 52-inch strip light was designed to be used as an accent light, I also use it as a main light occasionally. In this case, I use the egg crate diffuser on the front to help me control the light, making it a more precise and effective tool. Using kickers as both the main and edge light is a huge factor in the lighting magic of many of my images.)

Hair Light. The hair light creates a separation between the subject's hair and the background. In a similar

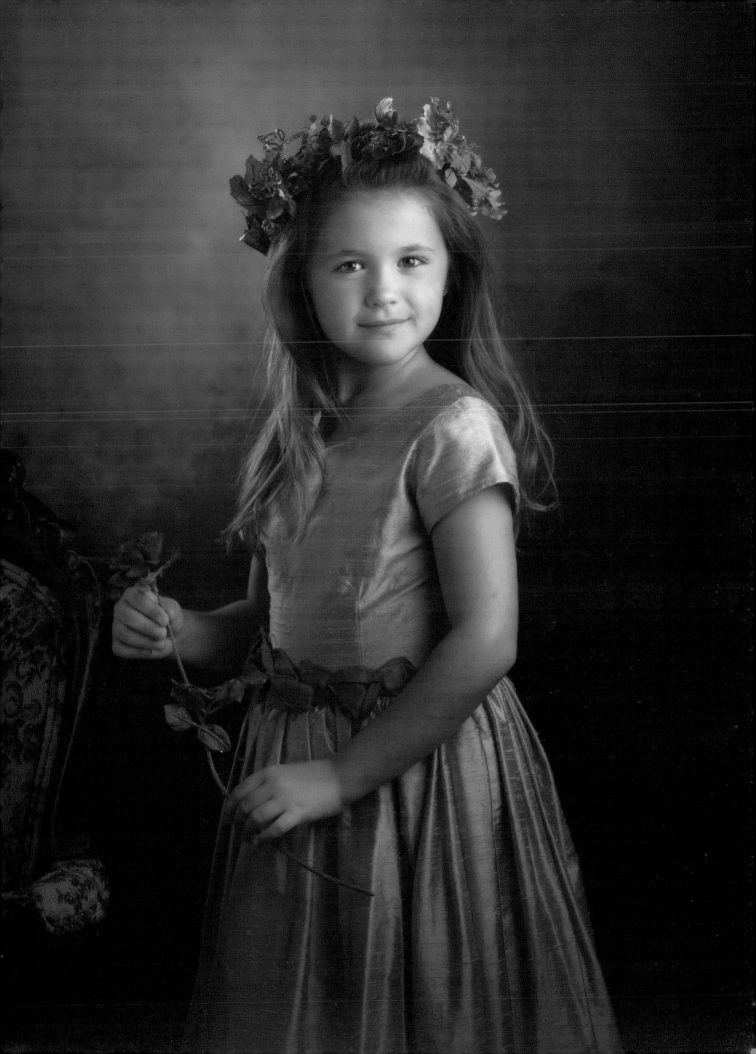

fashion to the kicker light, the hair light is used to create an edge around the head and shoulders of the subject. I rarely use a hair light in my work, because I find that children do not necessarily stay in one place long enough to make the hair light effective. Also my use of the kicker light produces the same separation of the head and shoulders that a hair light would.

Background Light. The background light is used to determine how much of the background the viewer will see. When working with strobes on a mid- to low-key image, it is a good idea to keep the background at a slightly lower exposure than the main light to ensure that it does not detract from the subject. You also want to avoid making the background too dark; this will eliminate the sense of depth in the image. If you are working with high-key lighting, the background can be at the same or a slightly higher exposure than the main light to ensure that it maintains its clean white appearance in your final portrait.

Other Sources. There are many other possible light source for an image. In addition to your studio strobes, you may use an on-camera flash, tungsten lighting, or natural lighting to create your work. It is wise to always

be prepared—you may find yourself in a predicament that calls for emergency lighting. If you do, look around. You will be surprised at how many options you have. I have used everything you can imagine: mirrors, flashlights, and even the headlights of a car to create more light in an image. Being prepared is the best option, but in a pinch, being resourceful can save the day.

Lighting Accessories

Reflectors. A reflector, a device used to bounce light back onto your subject, is also high on my list of necessary tools. The good news is that this is one tool you can make at home if you are working on a budget. A simple piece of white foam-core board that is painted silver on one side works well. Once you master using a reflector, you may want to invest in something a bit more flexible and convenient to use. I have used many types of reflectors over the years and find the most convenient to be the 52-inch circular disks that pop open for use. I am also a huge fan of the Larson square reflectors. Both of these reflectors provide excellent light and the ease of use that is necessary when working with little people.

Scrims. Scrims look similar to reflectors, but they are used to block overhead light from falling on the subject (rather than reflecting light back onto the subject). I am a firm believer that almost every outdoor session is better when a scrim is used. By pairing the scrim with a reflector (or fill flash), you will be able to control the light direction, create gorgeous catchlights, and eliminate distracting light that may ruin the emotion or integrity of the image. This is known as subtractive lighting.

Stands. In additional to providing support for your studio strobes, light stands can be used for multiple pur-

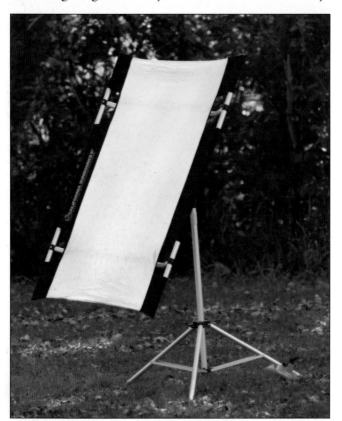
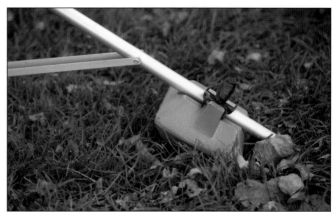

A scrim in use on location, with a closeup of the weight being used to secure the stand.

poses while working with children. When I am on location, I always carry two stands and two boom arms. One stand will hold my reflector and the other will hold my scrim. Having these portable assistants gives me more control over the image and frees me up to focus on my subject. When choosing a stand consider both the weight and the height.

Weight/Sand Bag. In a perfect world, we would all have three assistants to carry our equipment and hold things for us. However, I have yet to see that happen. When working on location, you will have many elements working against you. One of the most frustrating can be the wind. Therefore, it is wise to keep a sand bag with you to hold down your scrim stand, reflector stand, or both. The last thing you want to happen is to have your scrim stand fall over and scare your young subject—or, even worse, hit them in the head! This is one of those "school of hard knocks" lessons I have taken the trouble to learn for you.

Remote Slaves. Remote slaves are used to trigger your light source without the need for cords. These are definitely a luxury item, but I still put them high on the list of lighting necessities. Eliminating cords is a great idea when you have little ones running around. One serious trip on a cord could bring your light stand or camera crashing down. This would be a very expensive learning experience.

You can also purchase remote slaves that will trigger your camera. I have worked with these remotes for years and love the ability they give me to move away from the camera and capture the spontaneity of a little one. One drawback I have found when working with remote slaves to trigger your camera is that you need to check your focus often. If your subject moves even slightly and you are not behind your camera, you can quickly loose your best shots by not paying attention.

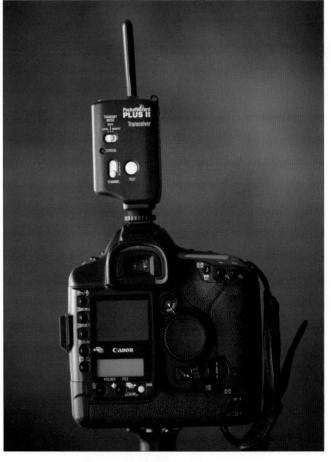

TOP—*Reflectors and scrims give you the control you need to shoot outdoor portraits with studio-quality results.* BOTTOM—*When additional light is needed, using remote slaves (here controlled by a PocketWizard attached to the camera's hot shoe) can help eliminate cords and make your studio safer for little ones.*

4. Lighting and Camera Techniques

Lighting Techniques

Truly the most captivating part of any image is the creative use of light and shadow. Through proper lighting you can create powerful and timeless work. From the soft separation of the sun as it naturally cascades across a child's head and shoulders in a sunny field of flowers to the deep shadows within a black & white relationship portrait, lighting is the tool that draws the viewer in. I can honestly say I still get excited when I play with light. Sometimes I feel like a master painter as I begin to study the light in a new location. I see everything as if it were an open canvas just waiting to be filled with light.

Many years ago, my good friend Ann Montieth was visiting my studio. As she watched me work in a session, she said, "Don't ever let another photographer see how you light. They will tell you that you are doing it wrong!" She was right. I have a very distinct style of lighting. I tend to push my lights to the limit. I almost use them as more of a kicker or sidelight than a main light. When using any light source, my goal is to define the

Sunlight rims the subjects, outlining them against the autumnal background.

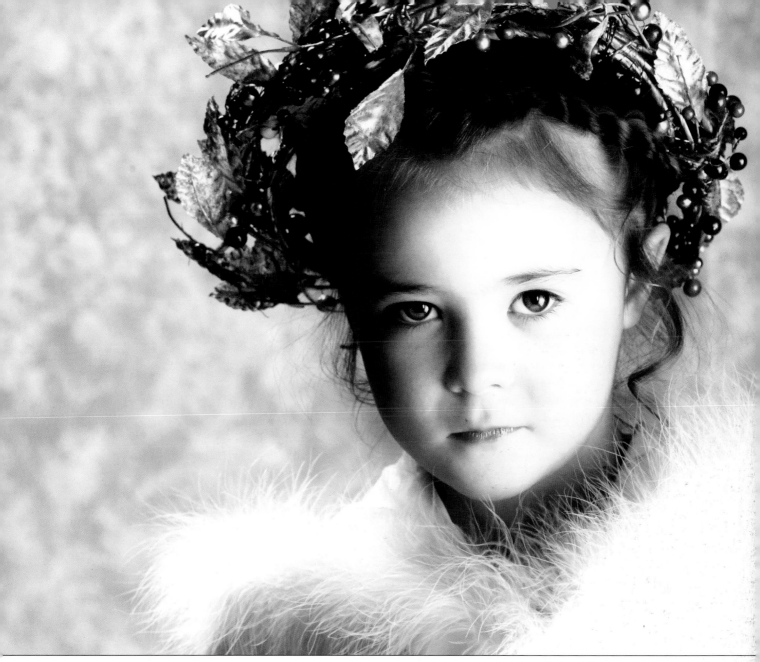

Catchlights make the eyes sparkle with life.

important areas and show shape by using shadows and highlights. Whether I am using the hard edges of a kicker light or the sun in an open field, I use whatever lighting technique will help me create the definition I seek.

Lighting Ratios. Lighting ratios are determined by measuring the difference in brightness between the light side and the shadow side of the subject. The higher the ratio, the greater the contrast. For example, if there is a 1:1 ratio, there is no brightness difference between the highlight and shadow sides. If there is a 4:1 ratio, the light side is four times (two stops) brighter than the shadow side. Most portraits are made at the 3:1 or 4:1 ratio, but you can try different ratios depending on the

look you want to achieve. Practice creating variations and learning to see how the light behaves.

Catchlights. A catchlight is a tiny reflection in the eye that draws the viewer into the image. These little highlights create a tiny sparkle that warms the image. Eyes that do not have a catchlight will look dark and void of emotion. Catchlights can be produced several ways—for example, a simple reflection from a window, a portable reflector, or a fill flash will produce pleasing results. The main goal is to ensure that the catchlights are found evenly in both eyes.

Low Key Images. Low key images are ones the feature predominately dark tones (and often black) in the back-

LEFT—*Low key portraits are often moody and dramatic.* RIGHT—*High key portraits are usually more open and gentle.* FACING PAGE—*High key portraits are a popular choice for portraits of newborns, creating a classic baby portrait look.*

ground, props, and clothing. They also tend to employ more dramatic lighting with deeper shadows than high key portraits. In this type of portrait, it is the lighter tones—normally the subject's skin—that draws viewers' eyes. Low key portraits have a classic look that really lets you focus on the subject of the image.

When I photograph a person in a low-key scenario, I can literally feel the light as I move the boxes around. I love to manipulate and change the lights until I find balance between highlight and shadow detail. My goal is to provoke interest by creating an outline along the important features and letting the rest of the image fall off into the darkness. This lighting technique is great if you want to create a more serious mood or you want to focus on the relationships that your subjects share.

High Key Images. High key images are ones the feature predominately light tones (and often white) in the

background, props, and clothing. They also tend to employ softer lighting with more open shadows than low key portraits. In a high key setup, your eye is drawn to the darker areas in the frame, making the skin tones more dominant and eliminating the distraction that some clothing may cause.

While it's not personally my favorite style, I create high key images everyday as a means of balancing out the busy patterns or bright, playful colors that my clients often wear.

You can create a timeless look by using white clothing on a high key background. This angelic style has been very popular over the years, and I can always count on its appeal to my clients. The most popular choice for my clients using a high key setup is black-and-white or denim-and-white clothing. These two combinations are the tried-and-true options. For a while, I even tried white

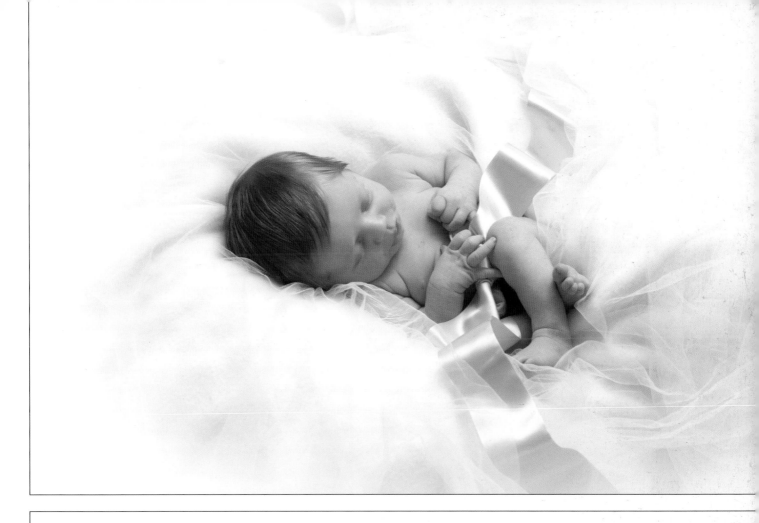

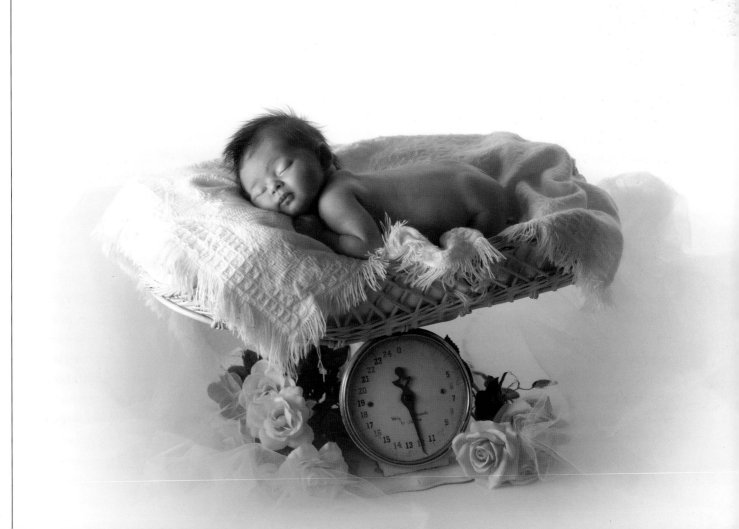

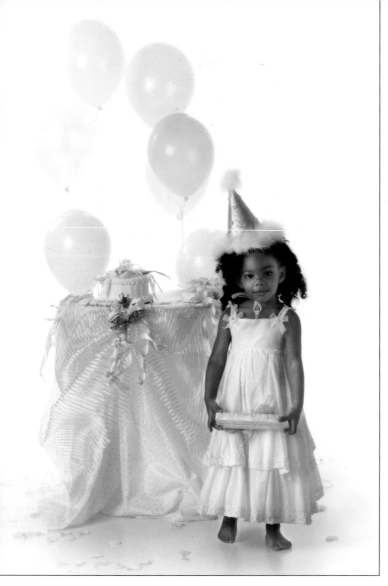

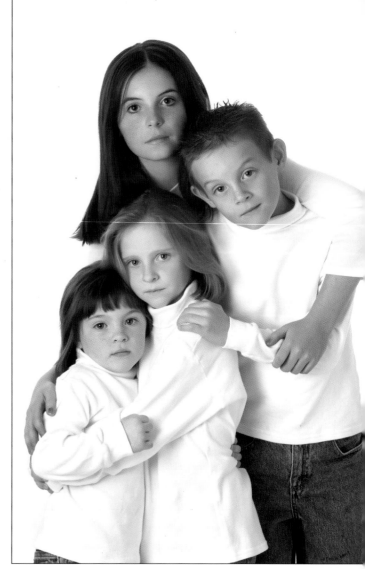

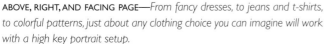

ABOVE, RIGHT, AND FACING PAGE—*From fancy dresses, to jeans and t-shirts, to colorful patterns, just about any clothing choice you can imagine will work with a high key portrait setup.*

turtlenecks for a reverse contrast look. High key is also recommended for almost every newborn series.

Although the goal in high key portraiture is to create even white light surrounding your subject, I still tend to position my main light on the side with a slight angle toward the subject, rather than directly onto the subject from the camera position. This enables me to push the light across the face and not lose any detail while maintaining the facial structure. I think it is important to control the highlight and shadow detail, keeping the light ratio in the skin tones just as I would on any portrait. I want the subject's skin to have enough shadow that the facial features do not flatten out. Remember, shadow creates shape. Chubby cheeks, little dimples, and button noses will be lost if you use flat lighting.

In my studio, a single 42-inch Larson Starfish with flags lights the entire high key background. This fantastic light provides an even wash across the background, making it a breeze to produce a clean white sweep.

Basically, a high key image is safe, because anything the client wears will look great. And, I should add that 50 percent of our clients prefer the simple, white backgrounds to the natural light and darker tones that we offer. This just proves that my personal opinion on high key is just that: an opinion.

Window Light. Window light is probably my favorite light to create with, because its soft expanse is flattering to every subject.

Having worked in many difficult window-lighting scenarios (including eight years in a studio with west-facing windows), I have learned that the most important issue is finding the right balance between the highlight and shadow sides of the face. In my old studio, we frequently used reflectors placed very close to the subject to reflect in a lot of light. Alternately, we had to block some of the window light with a scrim to avoid huge light-ratio problems. In the design of our new studio, we made sure that all of our windows face north, as this is the most consistent window lighting to work with. Because the sun rises in the east and sets in the west, using north window light ensures that you will never have the sun directly shining in your window. As a result, the light will be softer and more consistent throughout the day.

The key to handling any window light scenario is to understand your meter and take it seriously. If it says there is a 3:1 lighting ratio on the subject's face, you must modify the light to make it work. In the beginning, window lighting can be frustrating to work with. Once you master the skills required to handle the lighting ratios, however, you will be able to modify and control the light just as you do with your studio strobes.

Camera Techniques

Camera Position. When we work with children we often say that you must "get on their level." This not only means understanding what they are thinking, but in a more literal way, it means getting down on the ground. Yes, you must bend your knees and kneel. Don't be surprised if you even find yourself on your tummy sometimes. Having the camera at the child's eye level is important, because it creates the subject prominence you need to produce an effective portrait. Most strong images focus on the eyes, and if your camera position is too high, you will get more forehead than face. Conversely, if you are too low, you may distort the size and

Working from a ladder and shooting down toward your subject makes the child's eyes very dominant.

Using selective focus, you can completely blur the background and keep the emphasis on your subject.

shape of the face. Besides, who wants an image that is aimed up your subject's nose?

Working from a Ladder. Having said that you should normally get down low, I should add that very dramatic images can also be shot from atop a ladder. When a subject looks up, it creates an extremely powerful image. The eyes of your subject become very dominant. Combine this with a more serious expression, and you end up with a very striking pose. This is also a fun way to create some really neat angles, as well. Photographing children holding hands while lying on their backs or an older sibling snuggled up with the new baby are both powerful ways to create special relationship images that will become treasures. Oh—and you can expect a bunch of giggles

and wiggles, as well. Once you have your subject lying on the floor there is no telling where the fun will go!

Selective Focus. Selective focus means making a conscious decision about how much of the image to keep in focus and how much to allow to fall out of focus. One of the best ways to control this element is by using a long lens and a large aperture. My favorite lens is the 70–200mm f/2.8. Using this lens at the 200mm setting and its maximum aperture (f/2.8), I can throw a background completely out of focus. This draws the viewer's eyes away from any distractions and puts the full attention on the subject.

Using Grain. Back in the day, you could use a film with a higher ISO to create some wonderfully grainy im-

A bit of grain gives black & white portraits a very classic feel.

ages. The problem was, once the special film was loaded, you had to finish the roll before you could go back to a traditional (non-grainy) film.

All of that has changed with the age of digital. Now much of the creative process is left to the digital artist after the image is captured. If you want to create an image that uses grain as an artistic element, you can use a plethora of tools that will make this happen. Whether you push your camera's ISO or use the many diverse Photoshop actions, you have total control over quantity and quality of the grain used.

Grain can be used to create depth, or give an image an old-time effect. (*Note:* Grain can, of course, also be a neg-ative factor if caused underexposure or over-enlargement. This type of grain is a distraction and will give the final image a poor quality.)

5. Designing Portraits

Clothing and Accessories

Clothing Colors. In my art, I tend to prefer working with dark tones over working with lighter tones—but I am always careful to listen to what my clients prefer. If they have no opinion or decide to trust me, then I select darker options from the clothing selections they brought or pull something dark from my closet. Ultimately, when you are selecting clothing for a session your focus should be to remove all distractions and make the face and the eyes the strongest elements. This can easily be accomplished using dark clothing and a dark background. This combination can work well for traditional work, formal work as well as black & white relationship studies. (For more on this, see page 41 on low key portraits.)

Midtones are my second favorite tone to work with. I love the way a cream or ecru sweater looks against the skin. By selecting a similar background, the color is becomes less dominant and the subject's eyes remain the most striking feature of the portrait; everything else in the image becomes a monochromatic pallet. It's very dramatic to photograph these neutral backgrounds with more serious facial expressions because of the timeless, soft feel that these tones create. (*Note:* Other colors that work well with these neutral backgrounds are soft, spring-like tones. Pinks, light green, and other pastels can all be used to create a soft spring-like effect.)

Clothing Style. The clothing style must suit the background and pose. For most portraits, simple, casual clothing is best. Kids will feel most comfortable in these clothes, too. Many sessions, however, call for a more formal look. This might include a Holy Communion, a special dress for another formal occasion, or the need to match a previous formal portrait.

Relationship portraits are most effective when bare skin or dark clothing is employed.

Glasses. Although glasses are not really an accessory, sometimes they must be worn during a session. It is important to understand this can be a sensitive subject for a young child, so be very careful as to how you approach the topic. Always address Mom first, in private if possible, and ask her if she prefers the glasses on or off. Also, always compliment the child and tell them how lovely the glasses look on their face. If Mom wants the glasses left on, let her know there may be glare and that it may cost extra to remove it. This usually convinces her that she should remove them for part or all of the session.

Occasionally a child will be in the process of a major eye correction that requires special glasses, which tend to be very thick and distort the eyes. They may cause the eyes to look much bigger than they really are. I always recommend that these glasses be removed for part or all of the session. I am aware that, due to the condition, one of the child's eyes will most likely wander. To compensate for the situation, many extra images should be taken. This is an instance when using digital capture really pays off. Keep in mind that if a child is used to wearing corrective lenses, his eyes will tire easily without them. You may need to take a break and allow the glasses to be worn for a while.

If glasses are optional, and no obvious problems will be seen, we recommend that the parent remove the lenses if they really want the child to wear glasses. Although my preference is no glasses, sometimes parents feel that they want to document the child's stages, and the glasses are a part of who they are. Many cute personality shots can be achieved this way, as well.

Shoes. We are a "piggy" studio—we love toes! From the wrinkled little newborn toes to a young child in an outdoor fishing scene, I love the timeless appeal that bare feet project. If the parents are willing, we even request that shoes be removed in family portraits.

My general policy is that unless it is a truly formal portrait, the children take their shoes off. Most of my clients know my policy and expect me to photograph barefoot portraits. There are times though, that a parent will feel that shoes should stay on. If so, I request that we do most

of the session with the shoes on, then take the shoes off for the last few portraits. (And most of the time, Mom will comment later on how much she loved the portraits with the shoes off.) If the shoes stay on, make sure that the bottoms do not face the camera. Also, the shoes should be cleaned and polished. We always recommend avoiding casual tennis shoes; these can be very distracting and draw your eye away from the important features.

If shoes must be worn, socks become the next important factor. A good pre-session consultation will have addressed this issue, but we keep a pair of dark socks in our emergency kit just in case. White socks can ruin a great image.

Hats. I love adding hats to an image. Hats show personality and can be the centerpiece of a profitable art product. We have many framing options and digital art pieces that hats compliment well. From a newborn's bonnet to preteen's baseball cap, hats show the many stages of growth and can really accent a child's unique personality.

Using this fun props adds an element of extra work, but knowing the limitations of shooting a hat in advance will make the session easier to handle. The primary concern is not to lose the catchlights in the subject's eyes. Without catchlights, your images will be dull and lifeless. By dropping the lights below the rim of the hat or using a reflector to bounce light back in, you will be sure to get good catchlights and ensure that the color of the subject's eyes doesn't lose any impact.

Hair Bows. Hair bows and barrettes are another prop that is subject to per-

Simple hats and bows often make a nice addition to portraits of little girls—especially when they are too young to have much hair.

sonal taste. As an artist, I feel that, most of the time, they are a total distraction and take away from the image. However, as a mother with two daughters who had very little hair their first year of life, I know that I also wanted to ensure that the portraits I created of my daughters had a feminine look. Bows helps accomplish this.

I advise you to keep a box of simple hair bows in a variety of colors in your studio. If you feel that a bow will complement the image, you can add it at you discretion. Sometimes a mom will bring in a head wrap that is much too large. Politely use this item for a few images, then recommend that you use a few of your smaller bows as well. Do not mention that you don't like her bow, just suggest that you should try a variety of options and decide later what looks best. I recommend that you create a few natural images without the bows as well— just to be safe.

Toys, Props, and Backgrounds

When I started my business, I did not have a big budget for props and backgrounds—in fact, I had *no* budget for these things. My first background was gray muslin followed by a white roll of paper and a big piece of black fabric. It was several years before I could afford to add anything else to my collection.

These simple backgrounds were also the basis for my prop selection. Although I had very little budget available, I found many things at garage sales and thrift stores that helped me start to create my style. Looking back, I am proud of my resourcefulness. To this day, many

of those first props still create winning images for my clients.

In the subsequent years, I collected many different props and backgrounds as my style has changed. In the beginning of my career—I call it the "white phase"—most of my props were toys painted white. This included a white tricycle, ladders, rockers, wagons, and anything else I thought I could get away with. All of these things were inexpensive and painted by me. At the time, I was quite proud of my work. However, as I looked at my competition, I noted that many of the chain studios were using the same props.

I became fascinated with creating unique sets, and around 1999 I entered what I call my "fairytale" phase. At this point, several suppliers were offering some majestic sets that were very realistic looking. I really loved these sets, and they certainly paid for themselves many times over. In fact, even today we have many sessions that include these sets; this fantasy-type work has always pro-

LEFT, BELOW AND FACING PAGE—*From simple props purchased at a thrift store to complex sets designed using elements designed especially for studio photography, when it comes to props and backgrounds, your choices are unlimited.*

More important than any set or prop is your ability to connect with your subjects and draw out their true personalities.

vided interest to the parents and excellent sales for the studio.

As far as accessories go, I feel that anything that will evoke a personal relationship with the image is ideal for a child's portraits. Some of the props clients bring from home are favorite stuffed animals, flowers, dolls, fishing poles, grandpa's hat—whatever will best personalize the portrait for them.

At this point in my career, I believe I am in my "simplicity phase." Most of my work involves natural lighting and very simple props. The average session involves a child, a chair, and/or a simple wall or background. Although simplistic, I feel that the focus of my work is truly

about the connection I feel between the child and myself. My goal is to create impact by using the subject's eyes as the window to her soul. If the final viewer can look at my work and emotionally connect, I feel I have done my job.

6. Composition and Posing

Composition

For centuries, artists have used creative compositions to thrill and delight their audiences. The basic principles these masters relied on remain the foundations for providing a pleasing portrait that today's viewers will enjoy for years to come. Therefore, one of the best ways to truly understand composition is to visit your local museum. We can learn volumes by studying the work of the many great artists who have paved the way.

Once you understand the basic artistic elements, you can supplement them with other techniques designed to create drama and introduce juxtapositions. Some of these techniques are as simple as turning your camera to create dynamic angles; others require preparation to execute.

Whenever you create, keep an eye out for new ways to change your work and develop your eye. Many people have a natural talent for art and quickly see all of the elements required for a pleasing image. Others, like myself,

Keep your eyes open for new ways to compose images and present your subjects in flattering ways.

Leading lines, like these railroad tracks, can contibute to an effective composition by drawing your eye toward the subject.

pecially the creative use of foreground, midground, and background, will assist in this artistic endeavor.

The foreground is the part of an image that falls between the camera and the subject. This can be used to create the depth needed to draw the viewer into the image. Using foreground props, backgrounds, or a natural landscape elements (grass, trees, etc.) are all ways to enhance this sense of depth. It is especially important when creating environmental images to consider the importance of the foreground.

The midground is where your subject will be found and is usually the point of critical focus. This means that the area in front of or behind the subject may fall out of the focal range.

The background is anything beyond the subject. This is a very important compositional element as it creates the final appearance of depth of the image. You can control this element by using lighting and depth of field to accent it or subdue it. It is important to understand how to light and compose your background properly so your subject remains prominent in the final image and is not lost in the detail of the background. A background that is poorly lit or totally in focus may draw the viewer's eye away from the subject.

Leading Lines. A leading line is any linear element in the scene—such as a road, tree trunk, river, fence, or elongated shadow—that the eye naturally follows. When an image carefully composed, these lines lead the viewer's eye into the frame and toward the subject. This draws people into the image and toward the primary point of interest.

Horizontal *vs.* **Vertical Compositions.** Choosing your image orientation is important. Not only do you

have more passion for photography than a natural talent. In order to develop an eye for photography, I had to spend a lot of time studying other artist's work—as well as my own. Each session you create should be evaluated to determine what needs to be improved and what worked well.

Key Elements. Many elements go into the creation of good composition. Understanding these elements, es-

need to know what aesthetically looks best, you need to know what your client's final usage will be. If your client mentions she would like something above the fireplace, a horizontal image would be appropriate. However, if she has an art niche, a vertical image may work better for her needs. Asking her questions in advance will ensure that you provide the perfect wall portrait for her needs. I also consider the pose and the elements to be included in the image. Props, walls, or doorways with prominent lines may also affect my choice.

Most portraiture is created in a vertical format so the viewer is drawn to the prominence of the subject, who is usually relatively large in the frame. When selecting a vertical shot, my general rule is to follow the lines of the image. If the child is standing, seated, or will be shown in a three-quarter-length pose, most often these images are taken vertically. This composition eliminates any extra space around the subject and makes the subject more dominant.

In vertical images, the subject is relatively large in the frame. In horizontal images, the subject is generally somewhat smaller and more of the environment is included.

When working with multiple children, or when creating a storytelling image where the setting and props are important, the horizontal format usually works best. This format generally softens the image by taking away the dominance of the subject (who is usually smaller in the frame) and drawing the viewer into a visual journey through the image. Horizontal images are also best for wall portraiture. They also tend to present well in larger

formats—it is easy to recommend a 30-, 40-, or even 50-inch horizontal print to a client, since most walls in the average home have a horizontal orientation to them.

Using Angles. Although vertical and horizontal orientations are important, many of my favorite images are made when I tilt the camera off its axis and use creative angles to get the shot. I love the dynamic leading lines that can be composed when shooting this way. It helps to do a few practice sessions and get a feel for what direction creates what angle. Once you have it figured out, you can use angles to produce movement and life in your work.

Rule of Thirds. The rule of thirds is one of the most important tools for creating powerful images. If you study the great artists, you will find this rule at work in many of the images. Basically, the rule of thirds states that if you were to draw imaginary lines dividing the image into thirds horizontally and vertically (imagine a tic-tac-

When composing according to the rule of thirds (below), the center of interest—usually the eyes or the face—should be placed along a line or at the intersection of two lines (left).

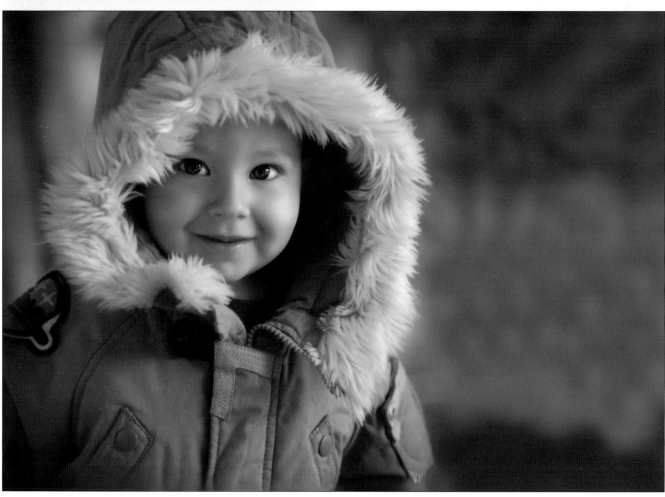

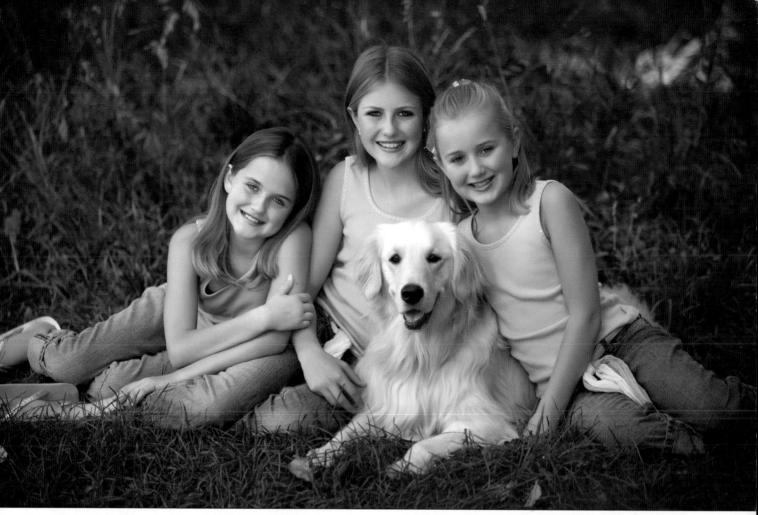

Triangular compositions are a good way to group multiple subjects.

toe board superimposed on the frame), important subject areas should fall on the intersections of the lines or along the lines. For example, a person's face might be located at the upper left intersection to give it prominence. Experimenting with this formula will make you more aware of your options when composing a scene. Although using this rule can create very strong images, sometimes breaking this rule can create dynamic images as well.

Color Harmony. In any library, you will find numerous books on color harmony and balance. These theories are important when you are considering colors to use in a portrait. Colors can be used to create a mood or a feeling within an image. Soft pastels and lighter colors such as pink, white and sage green give an image a soft and gentle feeling, while bright colors like red and yellow can be used to convey power or control. Remember that colors are often associated with feelings. As an example: blue can be sad, yellow fast or happy and red can convey danger or excitement.

In composition, colors also play an important role in directing the eye. Warm colors (like red and yellow) tend to advance, attracting the eye to them. Cool colors (like blue and green) tend to recede, reducing their visual prominence. Therefore, a child wearing a red sweater in a green forest will tend to stand out more than the same child wearing a green sweater in a scene of autumn leaves. Additionally, the brightness or darkness of colors can play a huge role in keeping the viewer's attention on your subject. For more on this, see the discussion of high key and low key portraits on pages 41–46.

Triangular Compositions. Many group or sibling portraits are created using a triangular composition. These poses create more balance and stability and also help the viewer's eye travel from one subject to another in a pleasing and gentle manner. When using this formula, you must consider each subject's size in relationship to each other. The older siblings may become the stronger support on the outside, and the younger siblings may fill in the inside areas. Using this composition along

with designing the clothing selection can minimize distractions and create a strong final image.

Framing Your Subject. Using framing elements on either side of (or all around) your subject is a good way to keep the viewer's attention on the subject. Often, you can find natural ways to frame your subject using doorways, window panes, or other architectural features within a background. This also helps to show the relationship between your subject and the background. For example, a young boy standing in a large doorway with a serious expressions, or a little girl gazing through a window while she has a tea party with her favorite stuffed animal, creates a gentle feel that will warm any viewer's heart.

Creative Cropping. Cropping is one of my favorite ways to change an image and improve its composition. Cropping can be done several ways including moving the camera position, working in Photoshop, or by trimming the finished print. By using these varying cropping options you can change an environmental image to a portrait in seconds.

When I am shooting with a long telephoto lens, I generally compose a full-length pose and then apply three different in-camera crops to the pose to change it up. This may include a full-body shot, a three-quarter-length vertical, and a tight horizontal headshot. Using this easy system, I can create more poses within a portrait study without moving the subject or camera position.

Cropping can also be applied after the image is created. This is when you can experiments with other artistic options that are generally unavailable in-camera, like panoramic presentations and square images. These are highly custom looks and are well received by clients. Be careful, however, not to eliminate too many pixels when cropping in postproduction; this can cause your image to pixelate and look grainy or out of focus. For optimum image quality, it is best to make your basic crop in-camera, then do slight modifications in Photoshop.

Posing

Perfecting children's portraiture requires a lot of patience and a great attitude; many of the rules of photography are thrown out and replaced with the "Law of the Jungle." Although I try to follow the rules, success depends to a large de-

Framing devices, like the architectural elements in this image, help tell a story and keep the attention on your subject.

gree on the child's attitude and willingness to listen. As I always say, sometimes we must settle for fun, and let perfect go off into the universe! So I have a good time with the kids and know that Mom and Dad will never recognize that I have missed a tilt as long as I get a great expression. If the child is nearing the end of his patience, I will let a shirt go untucked or a hair be out of place, because I know that time is limited.

Head Tilt. The basic rule is that girls tilt their heads towards the lower shoulder; boys tilt their heads toward the higher shoulder. At about three years of age, children can start to take direction on tilting their heads. Understand though, that children are very literal—if you say "tilt," they are going to *really* tilt. Many times, you will need to physically help them by positioning their head. Don't expect the tilt to still be there every time you get back to the camera, either. When I pose a child's head, I will walk back to the camera while never taking my eyes off of them. I gently coax the child to not move and then—snap!—I get my shot.

Arms and Hands. There are many formal rules that deal with arms and hands. For instance, it is best to never crop any body part at a joint; this creates a disquieting feel. You should also not have fingers or hands pointing toward the camera; they should always be directed away. I try very hard not to break this rule.

When it comes to arms and hands, one of my pet peeves is not using a proper support arm. You must find natural poses that do not seem forced or uncomfortable. Leaving an arm stiff or in an awkward position will not only be a distraction in the final image, but the child's discomfort will be obvious in his expression. When it comes to posing arms or hands, I always prefer a natural

and less formal approach when working with children.

When working with more than one child, the oldest child's arm and shoulder should be placed behind younger siblings. I want the younger child to be near his sibling and not hidden behind his body. These natural poses show the relationship and bond that the siblings share and also reflect the appropriate size ratio.

Legs and Feet. There are two leg poses that I generally use when working with children (see page 45 for examples). The first is the boy pose. This is created in a

ABOVE—*When posing siblings, placing the children close shows the relationship. Be sure to keep the younger child in front and not hidden behind the older child.* **LEFT**—*Rules are made to be broken—and sometimes the child's natural pose is just too cute to resist!*

seated position with the legs to the side and one knee bent. (*Note:* It is important that he not be seated flat on his bottom, as this will draw attention to the groin area.) The boy then places his elbow on his raised knee and makes a slight fist. Make sure his pants are pulled down to cover his socks.

The basic girl pose is similar, except that girls will have both legs off to the side and extended slightly. The palm of the girl's support hand should be flat on the ground with the fingers pointing away from the camera. The other hand can be across the leg, although I prefer to place it on the lower thigh.

Many other simple variations can be created once you have achieved these two positions.

The one pose we almost never use is what we all know as "Indian style" (or "criss-cross applesauce" for the younger and more politically correct). This pose flattens everything out, and using it makes it is impossible to cre-

ate dynamic head, shoulder, and body tilts. (Of course, every once in a while, a child sits in that position and it's just adorable—so even my strictest rules can be broken.)

Expression

Controlling all of the variables that go into a perfect image is not always so easy. Looking back at my early work, I often cringe at the lighting, exposure, and compositions I used, because now I recognize my mistakes. But whatever little mistakes you might make in creating your image, I have found that if you capture the real expression of the child—one that will emotionally move your client—the other flaws will be overlooked.

A child's smile or laugh evokes an emotion that can melt hearts, but that does not mean that the subject needs to be all smiles during the session. Sometimes a soft look or even a sad pout will stir the same emotional connection. When the subject does not smile, the eyes are also at their fullest shape; they are warm and inviting and can capture the viewer's heart. During a typical session, I provide an even mix of these expressions. Your client trusts that you will capture the complete essence of their child. This should include a full range of emotion and personality.

When I select images for my studio samples, I am always drawn to the more somber images where the subject is not smiling. However, I understand that my clients' expectations include a healthy balance of big smiles as well.

Portraits with great expressions practically sell themselves. When the expression is perfect, almost nothing else matters.

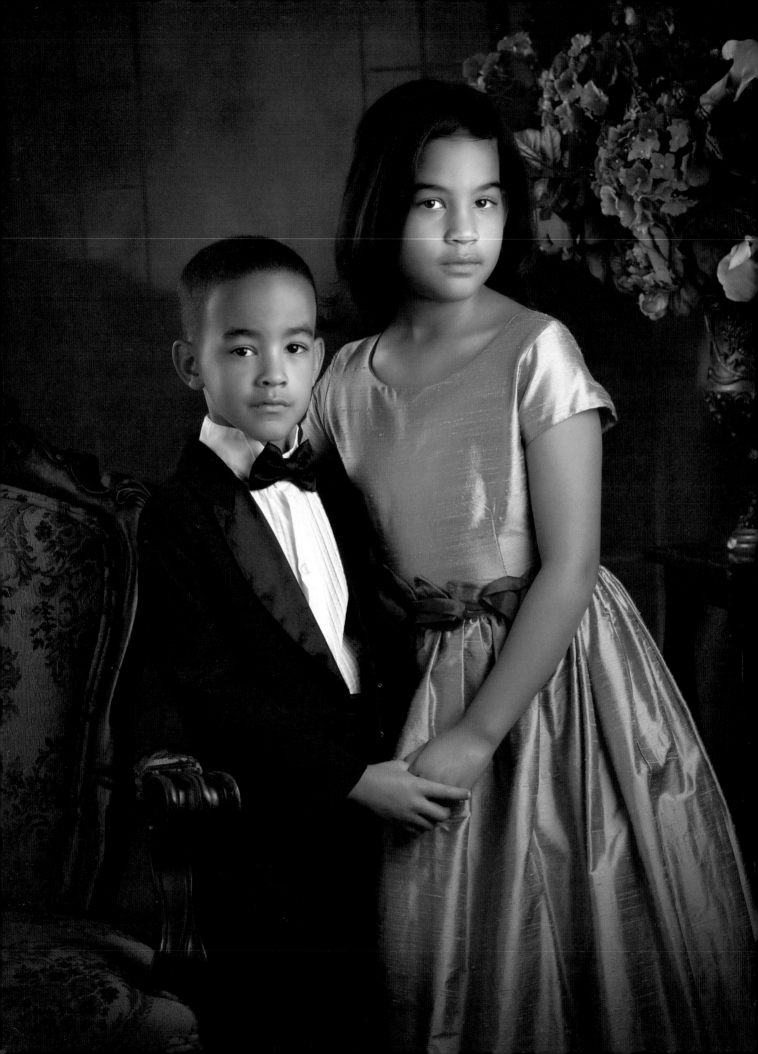

Real Life vs. Portraiture

In the photographic industry it seems that most photographers specialize in either real life studies or traditional portraiture work. My original efforts were to become a portrait artist. However, over the years I have seen my work go from a formal approach to a much more casual style. I am glad that I paid my dues and learned traditional portraiture in the beginning. Following those original guidelines are what makes my "real life" images look natural—yet very different from the snapshots Mom can take at home. Knowing the rules of photography is critical to breaking them in just the right way.

Real Life. A real-life image is one that is all about personality. These fun and very candid shots are used to tell the story of who your subject is and what they are like. These images can use a variety of personal props and backgrounds to make them successful. Whether it is a day at the park or a jump in the pool, capturing the essence of what childhood is about makes these images some of the most entertaining to create.

Even though these playful images are less contrived, it is important to understand that you must know the basics of good photography and not rely on the "shoot-a-ton-and-fix-it-in-Photoshop" attitude. You must be prepared with all of the tools to make this session a suc-cess. Proper exposure, excellent lighting, and great use of props will ensure that you can enjoy the moment and capture the real personality of your subject as well.

Portraiture. To me, a portrait is a posed image that has clearly been staged to perfection. Whether it is done in formal attire or more casual dress, the subtle use of backgrounds, props, and other amenities will determine the quality of this type of work; they must never distract from the importance of the subject. A traditional portrait can be full- or three-quarter-length and is rarely a tight headshot.

FACING PAGE—*A portrait is a staged image that has been executed to perfection.* **ABOVE**—*Real-life images capture a candid moment, but with a style that goes beyond the mere snapshot.*

Black & White vs. Color

Black & White. I generally use black & white to show the relationships that my clients share. Black & white images have a way of removing all distractions, and the tonality drives your eye to the lightest part of the image, creating great impact. I almost always include a black & white study in my newborn work. It is perfect for creating a balance between the parent's size and the child's size. I also use black & white images to show harmony in family work. When photographed in black & white, all of the subjects become a part of a complete canvas and the family group maintains balance—regardless of the children's ages.

Color. Most of my clients prefer at least some color studies during their session, and I love to work with the complete palette that life has to offer. The process of selecting backgrounds to bring out a child's eye color or using color to create harmony between siblings fuels my artistic passion.

Over the course of my career, I have tried brights, darks, pastels and everything in between, but I most enjoy using soft, subtle colors in clothing and backgrounds—colors that won't draw too much attention to one another. Neutral tones, in particular, are very unobtrusive and can hold a viewer's attention longer than most bright and colorful scenarios, which may overwhelm the subject. Those fun palettes have their place, but with my children's work I find that I want a timeless appeal that will last for generations to come.

Environmental Portraits

Because of the local weather conditions, four months out of the year, I create portraits almost exclusively in my studio. During those cold months, I love working with all of the props and backgrounds that I have amassed over the years.

However, when it comes to what the client will invest more in, the proof is really in the final sale. Our session averages are almost three times higher on our location work than our studio work. This tells me that I should work outdoors whenever possible. This is also the reason why our session fees for indoor and outdoor work are the same. I want my clients to chose the style they prefer and not be tempted to go with a less expensive session.

FACING PAGE—*Vibrant colors are well suited to this little girl's vibrant personality.* BELOW—*For a classic baby portrait, you can't go wrong with black & white.*

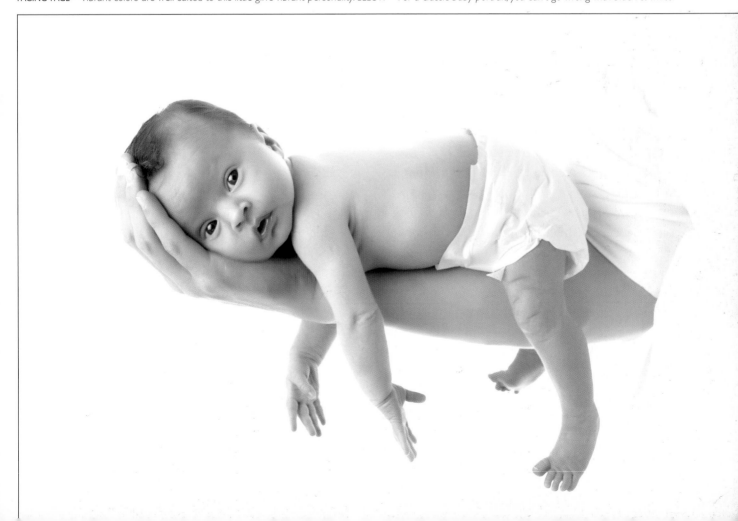

There's just something special about a casual outdoor portrait—parents love the images and kids are always more relaxed than in a studio setting.

There is something about the casual but majestic feel of an outdoor portrait. Because type of portrait tends to be more relaxed and less posed, my clients tend to enjoy the session more. They also feel a greater connection to the image because it shows not only the family's relationship but also a small piece of the community that they live in. Most clients love the area that they live in and want to see its natural beauty included in the image.

These images are also excellent for showing size ratio between the subject and the world. A little girl in a white dress standing in an open wheat field or a little boy sitting on a rock and fishing in a pond are both examples of using the environment to tell a story. Often, we want the child to look smaller and less dominant, showing the wonder of the big world he lives in. Clothing and props can be used in these images to tell a story, and the child may not be looking directly at the camera but shown engaged in an activity of some sort.

An additional benefit of working on location is that it provides your subject with an exciting experience that is far less frightening than a typical studio atmosphere.

Look at it from the child's perspective. A studio can be a big, dark room that requires a certain amount of separation from the parent. The child might also be required to change his clothes. This can remind them of the doctor's office and getting shots! On the other hand, an outdoor location is familiar to a child. Within minutes, even a very shy child can be motivated to chase a butterfly or search for tiny bugs. Being outside opens up a world of possibilities to create timeless portraits. By having a child dance in circles, play on swings, or just walk down a path holding a favorite teddy bear you can engage them and make the whole session fun—for the parents, the child, and for you as an artist as well.

The six to eight locations we work at provide a variety of natural settings that appeal to our diverse clientele—from local parks, to landscaped gardens, to open wheat fields, and even the Rocky Mountain range. These locations provide wonderful options to create portraits in styles ranging from very casual to completely formal. Additionally, our clients are excited to come again every year for a different setting.

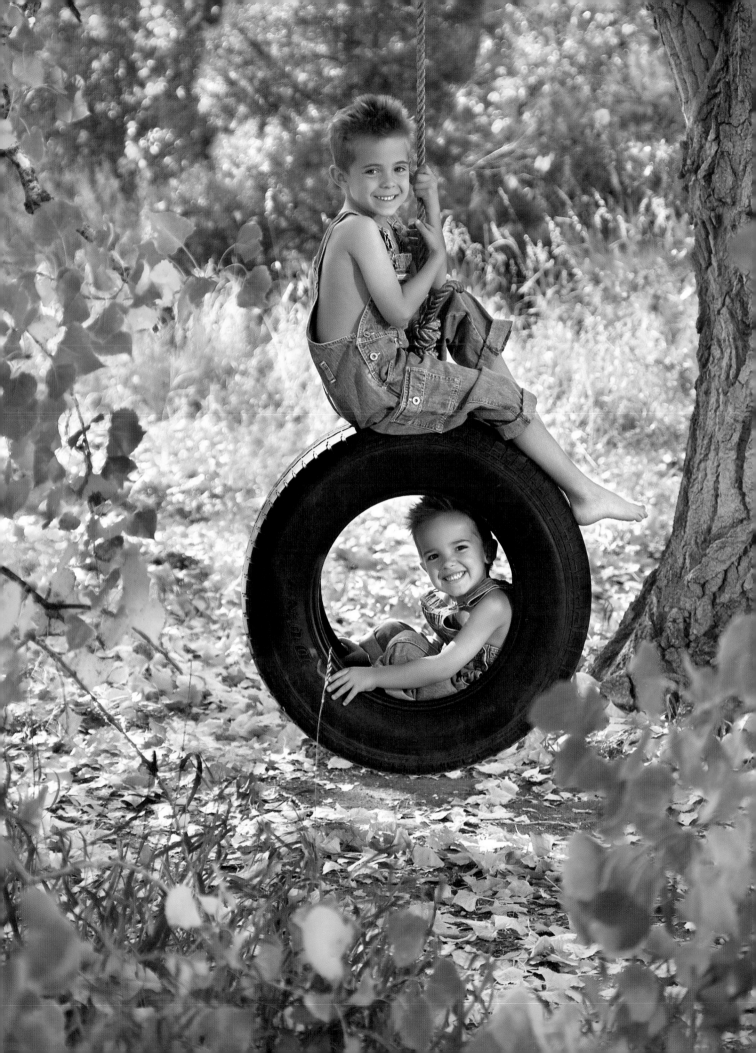

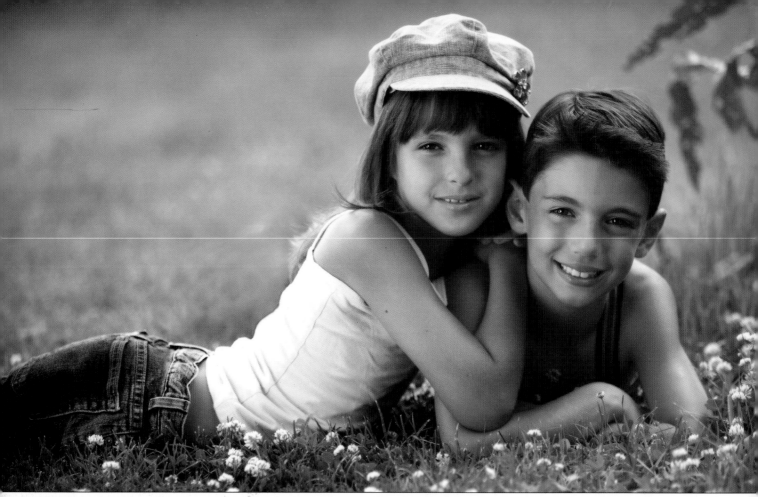

We book a full day at each location, allowing us to photograph about eight one-hour sessions.

Scheduling. It may not be cost effective to schedule individual outdoor sessions for each of your clients. This would require that you pack your equipment, drive to a location, set up, create the session, repack your equipment, and drive home. This could potentially take the same amount of time as three in-studio sessions, negating the increase of revenue you want to see with an outdoor session.

We have a unique way of handling this problem. When I set up my schedule for the summer, I plan all my sessions for each day at a single location. In a given week, I may work at four or five different locations, but I only travel to one per day. This eliminates wasted driving and loading time.

I usually have a completed session schedule available by March. Once this is done, we can start the booking process. Because outdoor sessions are so popular, it is not unusual to have a waiting list carried over from the previous year for specific locations. This list is full of clients who have a particular look that they want for their next portrait adventure. By having a waiting list, we ensure

that our eager clients will have the first opportunity to reserve the best time for their families.

We book one session per hour, leaving a one-hour break for lunch. We start at 9:00AM, and our last session of the day is at 5:00PM. This means that, on an average day, I will conduct eight sessions. During the busy months (August to November), we will also add 8:00AM and/or 6:00PM sessions as needed. We request that clients show up about fifteen minutes before their location session and wait in the car until we are ready for them. I love to see the enthusiasm when a child arrives. Most children are so excited to be outside, they can't wait to get started—and I'm sure that is a relief to Mom as well.

With this system, we get to spend every glorious day outside. It makes me feel like I have the greatest job in the world! I get to eat my lunch outside under a big tree everyday, play in streams, and enjoy the warmth of the sun. And if a client cancels at the last minute (usually due to a sick child), I can lie back in the warm grass and count the leaves for a whole hour. What could be better?

Consultation. In order to provide excellent customer service, we prefer to have an in-studio consultation about a week or two before the session. This gives us an opportunity to ensure that we are providing the right "look" for our client.

When your client comes for a consultation, you should provide them with wardrobe and styling information and show them samples of other sessions that were taken at their desired location. Show them a range of poses and clothing styles to ensure that they know how to prepare. You should also provide directions and your cell phone number in case they have trouble or get lost.

Your clients should also be given a clear explanation of the possible weather issues. Make sure that they know to plan clothing that will keep them comfortable as you work. (For further tips on planning for shoots in any season, see pages 77–79).

One of the nicest advantages of location work is that almost any style or color of clothing will work. From bright patterns to soft pastels, clothing can show personality and style. We also keep a supply of classic clothing in our van. Some of the favorites are any combinations of denim, white, black, or pastel colors. In the fall, I love working with earth tones like brown and dark red.

Preparing for the Shoot. I have been a location shooter for many years now, and one of the greatest tools that I have found is the simple creation of to-do lists. These lists help us ensure that we have all of our ducks in a row and that nothing gets missed. These list have become our guidelines for everything we do. We have a standard list that is used for loading the car with our equipment. For each "Limited Edition" special that we create, we also have a list of specific items that we may need to complete the scene. I am very serious with my assistants about the importance of these lists and believe in checking them on a daily basis. I have found that when we don't, we are always missing the one item we really need.

With outdoor portraits, just about any style of clothing will work.

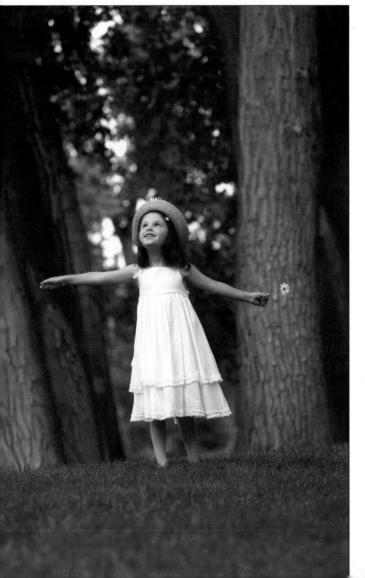

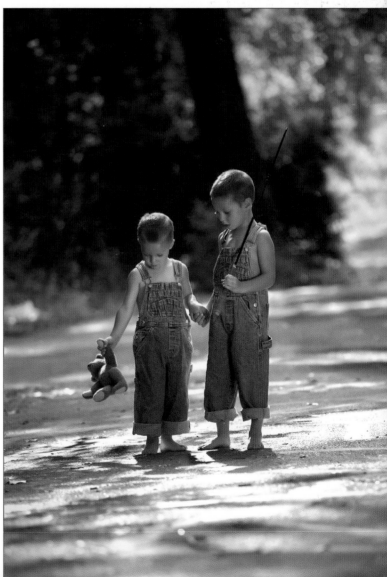

Additionally, our company van stays stocked at all times with the props, clothing, and accessories we need for working outdoors. Having a van dedicated to location work may be a considered a luxury item to some photographers. For many years, it was not in my budget either, so I always kept my equipment, props and various tools in one place ready to go. This made outdoor sessions nearly effortless as well.

Selecting Props. There are so many great props and accessories are available for working on location that is impossible to mention them all. For girls I recommend a tea table, an antique stroller, and a tree swing. For little boys, a simple fishing pole with a tack box, an antique tricycle, or an old wagon are great props. These items are easy to find and usually cost very little, but they are invaluable for getting kids interested in a session. Giving them something to play with takes away a lot of their anxiety and makes the session more entertaining. The best part is that most of my props are antiques, and the worn look adds to their charm and appeal.

Lighting. Because we work almost every hour during the day, we are often faced with difficult lighting scenarios. A location that looks great at 8:00AM may not be as usable in the afternoon. In Colorado, we also deal with weather that changes by the minute. In a single one-hour session we can have bright sun, overcast clouds, a bit of rain, and then back to sunny conditions again. Add to that mix the harsh afternoon sunlight, and you can see that we just never know what the day will bring. When I started my career, dealing with harsh and ever-changing lighting conditions was a huge challenge. Over the years, though, I studied the results of my difficult sessions and learned to compensate for these unusual demands.

Our company van (above) is stocked at all times with the items we might need on a location shoot—like the stroller seen the portrait to the left.

The simplest way to control your light on location? Shoot into dark areas.

Reducing Color Shifts. Before I discuss working with lighting during the various times of day, I would like to note the importance of keeping your images free from the color shifts that occur in these ever-changing conditions. To do this, I almost always use a silver or white reflector or a fill flash when working outdoors. All of these tools provide what I consider a clean white light that can virtually eliminate any shifts in the skin tone and shadow areas. This helps to accurately record the subject's skin tones and the colors of their clothing, reducing the need for color corrections in postproduction.

Morning Light. I love working in the morning. Not only is the light soft and consistent, I also find that children are generally at their best behavior and ready for the many adventures I have in store for them. Children often get tired after a long day of school or play. Working with them in the morning assures that their attitudes will match their wonderful expressions.

You will find that morning light will often add a blue or gray cast to the overall image. This can adversely affect the skin tones, leaving your subject looking gray or muddy. These tones are often found in the shadow areas of your final images, as well. This makes it particularly important to use one of the modifiers described above.

Afternoon Light. Afternoon light is by far the most difficult to deal with. The harsh shadows and bright backgrounds can make even the best photographer cringe with frustration. When I look at my work created even three to four years ago, I can see where I struggled to compensate for these unpleasant conditions. Afternoon light tends to create a strong green/yellow cast. If the sun is harsh and bright, the shift will be toward the yellow hues. On a less sunny day, your image may reflect the green grass and trees, resulting in a green cast in the shadows. Unlike the blue/grey color cast of morning light, this is relatively easy to blend away in postproduction—

but it still makes sense to prevent the problem as much as possible.

I have a few rules when I shoot midday. These have helped me get past the difficulties of this time of day. Two of these tips include:

1. **Shoot into dark areas.** I know this sounds very elementary however, by following this rule I have virtually eliminated the problem of balancing bright backgrounds with a child who is being photographed in the shade. When I look for a background, I always find something that is no more than one stop brighter than my subject's exposure. These shady areas provide the perfect exposure as well as create depth in the image. I can assure you that I photograph in all kinds of lighting scenarios; there are always opportunities to finding these types of backgrounds if you just look around. (*Note:* It's possible to compensate for a bright background with a stronger fill flash or by bumping your shutter speed, but I find that when dealing with difficult color shifts or heavy contrast areas it is not worth the effort.)

2. **Scrim everything.** I also find that I prefer to scrim most of my work. By using a black scrim, I can virtually eliminate the distracting light that comes from directly above. Once I have blocked the light, I can use one of my light modifiers to fill in the shadow. This technique creates a wonderful contrast between the subject's skin tone and the surrounding background. The natural shadow separates and accents the final image. Of course, if a child is not cooperating, or it is impossible to use a scrim due to limited room or wind conditions, I will skip this technique.

Working in the Shade. Whenever I am working with a child, I know that I need to make the conditions as bearable as possible. Putting a child in direct sunlight is generally not conducive to a pleasant portrait. Because of the midday heat and the squinting due to the sun, we must find more appropriate solutions for this time of the day.

When selecting a background, look for a shady area that has an even quality of light. If possible, look for a natural reflector such as a light-colored wall or sidewalk to help reflect light into the shadows. Keep in mind that

The soft glow of the light makes late-afternoon sessions some of my favorites.

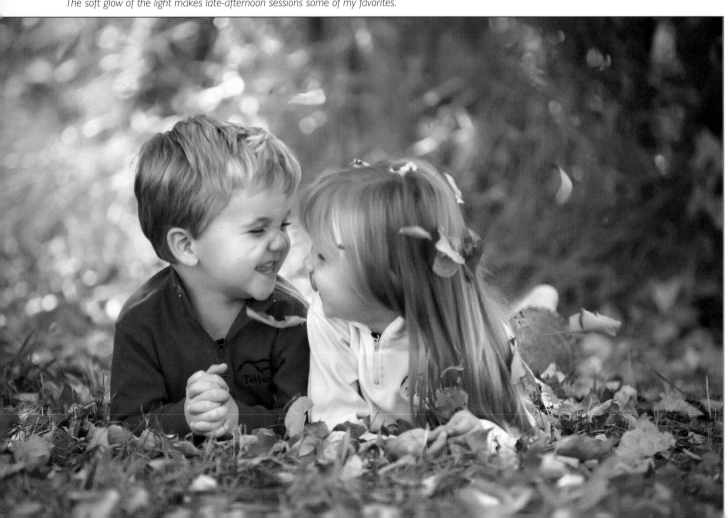

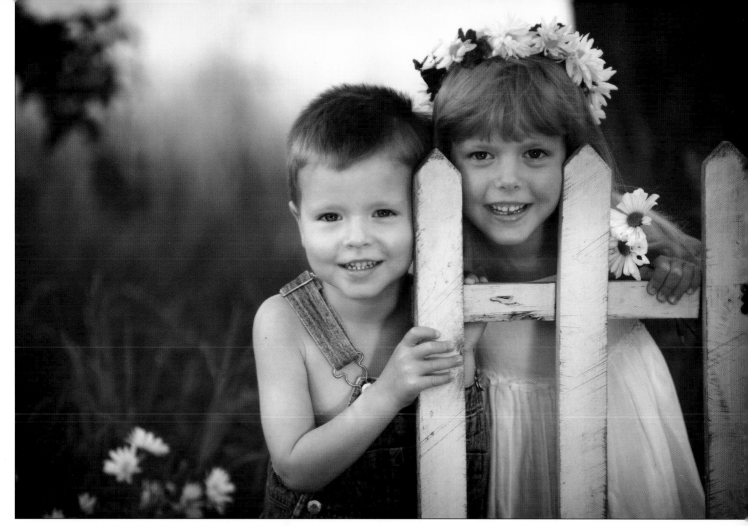

Spring flowers set the stage for a memorable portrait of this brother and sister.

most shady areas will still have patches of sunlight that stream down through the trees. Sometimes this can create a natural hair light; more often it is a distraction and should be removed with a scrim.

Late Afternoon. Late afternoon is by far my favorite time of day to create portraits. This warm and soft light is perfect for creating a mood and also provides an excellent natural glow to the skin—a soft and natural tanning effect that most clients appreciate. The biggest difficulty during that last golden hour of the day is that the light changes so quickly. This requires both constant metering and white balancing. Even thought there is a bit more work involved, however, the results are well worth your time.

Because I have a family that I want to go home to at a reasonable hour each night, I do not schedule many sessions during the evening light—until daylight savings time kicks in each autumn. Then the sun sets much earlier, so I can enjoy this magical time each day. Some of the best sessions of the year are created during these sessions.

The warmth of the changing colors with the soft sunset glow gives each image a magical look that is hard to beat.

The Seasons. Many areas do not have the same four seasons that Colorado provides, but even in the hottest areas of Arizona and the coldest regions of Canada, I still believe that providing the option for outdoor portraits is important to your business. You may need to evaluate your seasons and determine where and what time of year you will shoot outside. If you live in a desert area like Arizona that is scorching hot by 10:00AM, consider a 6:00AM session. If your clients will play along, you can create magical work. If you live in a place that is cold and snowy most of the year, great winter scenes can become your bestsellers.

Springtime. I am always excited to get started on my outdoor work, but Mother Nature ultimately decides when I will be able to work. In most cases, we start our spring sessions in May. At this point, the grass has just started to grow, and the leaves are out in full force. Mornings tend to be cool, so keep a jacket (and even gloves)

available in your vehicle. Also, keep a bottle of mosquito spray on hand if your area has those pests. There is nothing worse than becoming a springtime feast for these ferocious little bugs—and the little red welts are a disaster for retouching artists.

Rain is also an inconvenience during the spring season. We used to keep a rain day reserved for this issue. However, nine times out of ten it rained on that day, too. We now inform our clients that if it rains during their session we will do one of three things. First, if it is a light shower, we may wait it out. We explain that we will still be able to create a fantastic session even if their time is shortened a bit. If waiting it out is not a possibility, we will reschedule them on another day. Even though we are

The glorious colors of autumn make it my favorite time of year for portraits.

booked pretty solid, we can usually squeeze someone in at the beginning or end of a day. If that's not possible, we add them to a VIP list and call them every time someone cancels until we can add them back on the schedule. If they are flexible, we should be able to reschedule them within a few weeks. If their schedule is more rigid— they are only available for a Tuesday appointment at 4:00PM— we strongly suggest that we bring their session indoors and just complete it right away. It's hard to reschedule an outdoor session with such tight constraints and we don't want them to be disappointed by a long wait.

Summer. During the hottest part of the summer, we can expect little relief from the sun. Plan ahead for your comfort. Wear loose (but professional) clothing that will allow room to breath. Bring sunscreen and plenty of water to keep you protected from the rays and hydrated in the heat. Also keep a few camp chairs in your car so that you can rest in the shade between sessions. These chairs are also a great place for moms to sit and watch while you work. When we know it is going to be hot, we sometimes buy dry ice and provide a special Popsicle treat at the end of the session. This bribery is a sure winner during those hot days.

When the temperature crosses into the 100s, we cancel our sessions. It is just not wise to work outside in these conditions. First of all, it is not healthy for you to spend the day in that kind of heat (I have personally gone home with a serious headache that I am sure can be attributed to mild heat stroke). Most importantly, you cannot expect children to perform at their best if they are suffering from the blistering heat. A child that is hot will be miserable; he will move slowly, have flushed cheeks, and basically fall apart very quickly.

Autumn. Fall is my favorite time of year; I love the colors of the changing leaves. Children are excited that the holiday season is coming, and it is a great time to create images that will work for

We keep a snow-portrait waiting list on hand to use in our slower season.

holiday cards or gift portraits. Pets are also a fun addition to fall work—and bringing the family dog out for a day at the park can make a portrait even more special.

When the autumn season arrives, you can expect cooler mornings and varying temperatures all day. Keep a sweater and a jacket in the car—as well as a few blankets that you make available for your subjects to wrap themselves in between poses. As the weather turns more toward winter, expect some very cold days. Wear layers of clothing and keep gloves available. Recommend that your clients also wear layers (or even light jackets) for a great fall look.

Winter. Once the snow starts falling, we head back to the studio—but this does not rule out the opportunity for a great outdoor session. We are too busy before the holidays to deal with predicting snowfall, but we keep a snow-portrait waiting list on hand to use in our slower season. Clients are notified of this via our newsletter, and those who are interested in a very unique session in the snow simply call in to be added to the list. Once January and February arrive, we keep an eye on Mother Nature. The night before a storm, we call the waiting list. Because they are on the list, the clients have been instructed in advance to have clothing purchased and ready, so they almost always make the time to show up. These portraits

are really unique, and clients invest a lot of money to create a perfect winter scene.

Obviously, shooting in the snow can be a huge challenge, and you must prepare ahead of time to have a successful session in the cold temperatures and wet conditions. Once again, layered clothing and gloves are a must. You also must understand that your time is very limited; your clients, and especially young children, will not look comfortable for long if they are cold. Plan your session so that you know exactly where you will shoot before you arrive at the location. Your session will be short, so that extra preparation will make or break your success. Bring spare batteries for everything and keep them in an inner jacket pocket so the cold temperatures do not drain them. Hand warmers and other camping accessories often provide needed relief. We schedule two snow sessions per hour, then take an hour break to warm up. Providing a thermos full of delicious hot chocolate for your clients is a great way to get a few extra smiles at the end of the session, as well.

Studio Portraits
The types of images you can create in a studio are virtually unlimited—you have a level of control that doesn't exist anywhere else. In chapters 3, 4, and 5, we looked at

ABOVE—*Traditional portraits feature more formal attire and are usually selected for wall portraits.* FACING PAGE—*We also offer clients an oil-painted look in our traditional portraits.*

some of the technical aspects of creating studio portraits; here, we'll examine some of the styles of portraiture I use in my work. There are countless others, of course, but these have been particularly successful for me.

Traditional. Traditional portraits are the images that are best suited for presentation as wall portraits— but these three-quarter to full-length images must be nearly perfect in every way for the client to be willing to invest. This means every detail, including the way the outfit lays, the styling of the props, the expression, and body language must be perfect. My traditional work also tends to feature more stoic expressions and poses than my casual images. I prefer a soft smile to a big one, as I want to give the image a timeless appeal.

Traditional sessions, the clothing tends to be more formal. For girls, this may consist of a full-length dress, tights, and shoes. Boys may be in a sweater vest, a suit and tie, or even a tuxedo. Shoes and accessories must be clean, and matching socks are critical. Several small props may be used to make the session more personal. For in-

stance, to create a Holy Communion image we may feature a family Bible or a special rosary. In other cases, the boy may wear a special tiepin that belonged to his grandfather, or the girl may borrow a special piece of jewelry from her mother. We try to suggest these items at the pre-session consultation, because we know that these tiny details that will make a wall portrait easier to sell.

Even when creating a formal portrait, I reserve a few minutes of the session for a more casual study. This can be done without a clothing change; it is more of an attitude than a particular pose. I want to make sure I give the client what they came for and also give them a little bit of the style I am known for as well. This also gives the client more options for their final purchase.

As an add-on to our traditional work, we also offer oil painting as an option. I love the look and feel this gives an image. This work includes a painterly feel that is applied one stoke at a time creating greater depth in the eyes, lips, and facial structure. Almost any formal session will work well for this look. We charge a premium price

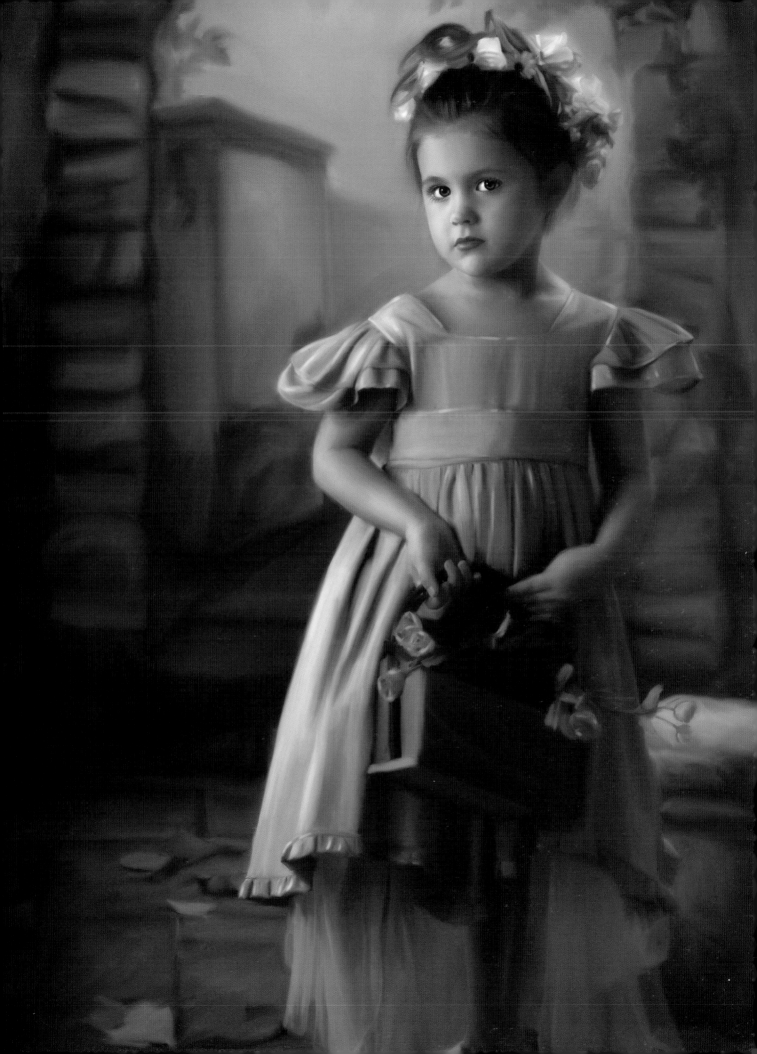

for this work, as it is very time-consuming and difficult to produce. Educate your clients about the efforts necessary to create this product and they will invest more to purchase this treasure.

Limited Editions. Limited Edition sessions were truly the springboard of the company I run today. In the early years, not many people were doing this type of work and the idea of creating an angel or a fairy was very exciting to me. My clients loved this new look and were very willing to invest in these creations. In the beginning, I had eight to ten different sets. Most were simple and easy to create, like the ballet sessions or dress-up days. After about three years, we had well over twenty sets. These sets were very comprehensive and included many large props. The sets were so popular that we were changing them out about every two to four weeks.

The Limited Edition concept went to the next level when we found companies that were producing walls and accessories to complement these ideas. Once we added these impressive props, our wall-portrait sales skyrocketed. I was so excited to see the clients' joy as they made substantial investments in our work.

Probably my favorite part of building these sets is seeing a child's eyes light up when they first enter the studio.

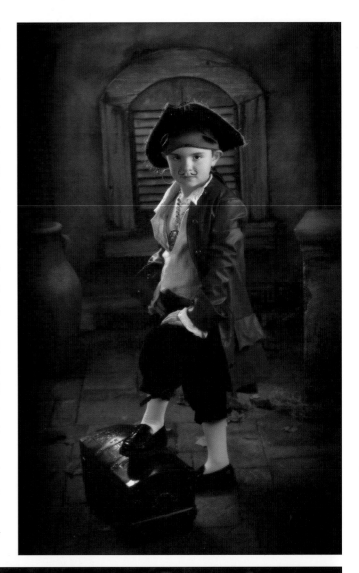

When children enter the magical world of a limited edition portrait set, their eyes light up and they are ready to interact with the world before them.

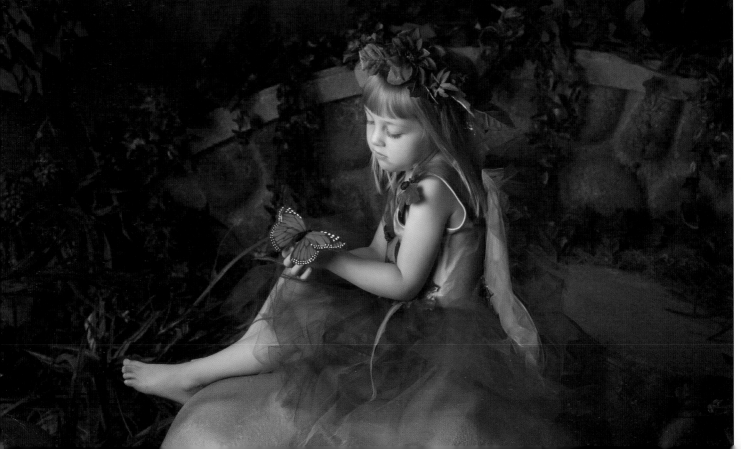

The excitement they feel radiates in the room—and even I can't help but be affected. I love to watch them study the sets and look at all of the details. All of a sudden they see a bunny or butterfly and shout with joy. These precious little moments are perfect for capturing the delight and wonderment that only a child can express.

During the session, I make up stories about the enchanting creatures that are a part of the set. My subjects become almost mesmerized as I talk about the bunnies and butterflies and all of the magical things that they do when no one is around. Once they are engaged in the moment, I say thing like, "Say hello to the little bunnies" or "Do you see fishes in the pond?" My subject embraces the fantasy, and soon they are telling me what we should say or do. Children radiate their feelings, and it is always obvious when they are having a good time. Sometimes they almost convince me that magical things really do happen.

Each set you create for this type of image will be an investment; the portraits won't sell if you don't put in the extra effort. When designing a set, you should think about creating depth through the use of foreground and background props. I also recommend that you book a few practice sessions for each new set so that you can become familiar with the lighting you will use. Lighting a complex set can be a challenge, and it is best to not to experiment on a paying client.

Shabby Chic. Shabby chic images are a big part of the work that I currently do. These images can be created using natural light or studio strobes. They can be created in the studio or even on location.

Essentially, shabby chic is an urban look including set elements that are appealingly worn or eclectic. The objective is to create a collection of odd props that, when

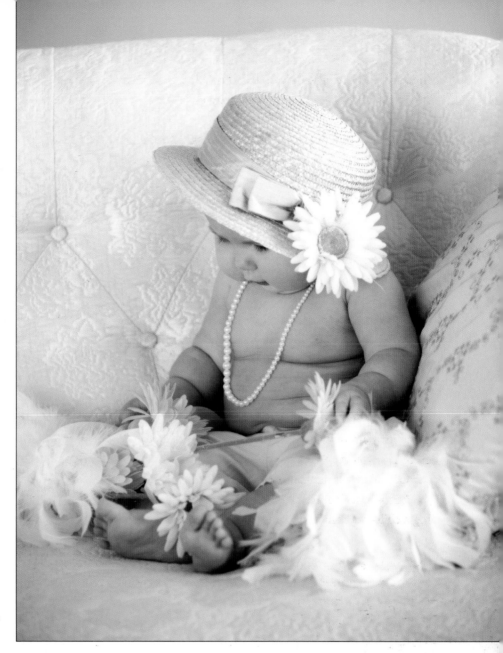

used together, create an appealing look. Most of the props I use for this style are things I find in antique stores—old chairs with peeling paint, worn-out couches that sag in the middle, window panes, old blankets or fabrics, fun hats, and beads are all used to create this look. The clothing selection can be simple slips or tulle skirts for little girls and denim jeans with no shirts for the boys. I often mix in the modern popular clothing that kids wear with much success as well.

Like all fads, I am not sure if this will stick around forever, but combined with the more traditional styles, shabby -chic offers my clients one more reason to invest.

8. Working with Kids and Parents

I t's extremely important for the photographer to be in control of the session. If you are going to be successful, you must convince both the child and the parent to trust you and your techniques. Start by establishing a good relationship with each. Speaking only to the parent excludes the child, and you won't be able to take fantastic portraits without creating some type of bond with your young subject.

Working with Parents

The "Never Say No" Rule. Children grow up hearing the word *no*—and when they do, it's almost always a negative thing that means stop or don't. From an early age, children learn that *no* means *no fun*. It is our job to create such a fun and festive atmosphere that children look forward to coming back to the studio to play.

> "If you can't change your fate, change your attitude." –*Amy Tan*

Often, preparing for portraits and driving to the studio can be a stressful situation. Parents may have certain expectations about the session and may be concerned that their children will not cooperate as fully as needed to produce the perfect portraits. Thus, the morning might include a mixture of threats and bribes with plenty of *nos* and *don't*s. Because of this, I try to speak only in positive terms, using rewards instead of negative terms with consequences.

During the Shoot. A portrait session may be a new experience for the child and the parent, so we try to make it as simple and pleasant as possible. When a parent arrives, I tell them that they are welcome to watch the session as long as they are quiet and don't interrupt. Nothing shuts down a session more quickly than a parent stepping in to direct their child.

I suggest that parents should not reprimand or scold their child during the session, noting that the studio is friendly and safe place, so kids are free to roam around and be kids. I also let them know that I will ask for their help if I need it. Additionally, I mention that, as a professional, I recognize a fake smile, so they should not tell their child, "That's not your smile." I'm pleasant when I say all of this, and I always have a smile on my face. Parents really appreciate a little direction—they feel much better when you tell them your rules.

Fortunately, I don't need to give a lot of instruction to most parents. Most trust that you know what you're doing and allow you to conduct the session uninterrupted. Occasionally, however, you will run into a parent who is so determined to direct the session. In that case, that you must ask them to step out of the camera room. I usually do this by explaining that their child seems very focused on them, and it would be better for my work if I had their child's full attention on me. I don't like to ask a parent to leave the room, but I will do it to spare the child a stressful situation. It's no surprise that the anxiety level in the studio instantly decreases once a disruptive parent leaves the room.

Keep your mind open—sometimes you can get your subjects into the spirit by asking for something other than the big happy smiles they expect to be prompted for at a portrait session.

Overall, parents can be very helpful. As long as you take charge and exude confidence, your clients will enjoy letting you run the show.

Working with Children

Of the 1,000 sessions I do each year, over 800 of them include children under the age of six. After so many years in the business, I have become an expert on working with little ones. Children are not impressed by your flashy equipment, years in business, or numerous awards collecting dust on your shelf. Children are won over with a generous smile, a sincere interest in their needs, and a patient and loving attitude.

Imagine a portrait-session day from the child's perspective. The morning is usually spent with a frantic mother who is projecting her anxiety like venom. Somewhere between the agonizing hair-do and the constant threats about keeping their clothes clean, the child is bound to start wondering what a visit to the portrait studio holds for them. The time spent driving to the studio may be a mixture of threats and bribes, which sends a completely mixed message.

By the time the youngster arrives, she is more than a little anxious. Is this scenario an exaggeration? Probably—but it's always safe to assume that the process of getting to your studio was at lease a bit of a challenge. Therefore, it is to your benefit (and your client's) to go

out of your way to make the session a positive and entertaining experience.

To help pave the way, I keep a stash of items that I can use in an emergency. I am convinced I could do my job without a camera—I could use a shoebox and a strip of film and make do—but there are a few other things I cannot work without. The following are a few of these "safety net" items.

Babies and Toddlers. *Silver Pom Poms.* These pom poms are the same ones that cheerleaders use. Babies are very attracted to shiny objects. The shine, along with the swishing noise that a pom pom makes, seems to capture their attention for long periods of time. I usually shake it

Babies and toddlers are often drawn to the soft shake of a silver pom-pom.

Feather ticklers are a big hit with older kids.

Sneezing. This silly game works well with babies that are six-months-old and up. Faking a sneeze and following it up with a soft "bless you" will elicit delightful smiles. As the child gets older, I also tickle Mom and instruct her to fake a sneeze.

Music. I recommend keeping a great variety of music on hand to soothe crying children, excite a toddlers, or even help preteens to smile. I always keep soft lullabies playing in the background when I work with infants. This creates a sound barrier that allows me to move things or change backgrounds without startling the child.

Baby Phrases. There are many baby phrases that are common all over the world. Some of my favorites are: "How big is [child's name[? Sooo big!"; "Peek-a-boo!"; and "Hands up!" I also ask the parents if there is a phrase or song that they sing when feeding or changing the baby. Most of the time, the parents will think of a special song that works. If not, "Twinkle, Twinkle, Little Star" is a great song to use.

Bubbles. As a last resort, bubbles have saved me many times. Because they are messy, I try to avoid using them—but when you have an upset child, nothing provides a quicker change of attitude. I am not sure where the magic comes from, but when I open the jar, smiles appear almost every time. (And here's a special piece of advice: don't store bubbles in your camera bag. That's another lesson I learned in Hard Knocks 101.)

Older Kids. Working with older kids means that you will be moving fast and having fun. Keep in mind that the tools I have listed below only work for short durations—then I'm on to something else. You must mix it up and keep the kids guessing at all times. This makes the session fun and keeps the children focused on what you are doing next, rather than how they can make it more difficult for you!

The Feather Tickler. This little device can actually used with kids of many ages. From a soft tickle on a six-month-old's toes, to full-on tickle torture, it ensures the appropriate smiles. Keep in mind, however, that younger children (six months to four years) can be afraid of it, so take it slow. If you pick it up and the child has an instant smile, feel free to tickle away. If they look concerned, try whispering to them that you are going to tickle Mom. They are sure to laugh. Alternately, hand the tickler to Mom and let her have the first tickle. Once they are com-

close to the baby and then slowly move back, keeping the baby's full attention.

Rattles and Bells. Small rattles and bells are another great attention grabber. Using these items along with a soft voice will bring the baby's eyes directly to the source of the voice. Sometimes it takes a few minutes to really get them interested, though, so be sure to not give up too quickly.

Soft Noises. Even though we all hate sounding silly, being a baby photographer means that it will be necessary to make a few cooing noises. These soft sounds are very much like the sounds a baby hears in utero, and they are some of the first sounds that he will respond to after he is born. Mothers are great at these noises—so if you need ideas, just ask your clients to jump in. I have found that each parent has a few special noises that their baby knows. Ask them to speak to their child and you will quickly be able to mimic those sounds. It sounds silly, but it really works.

fortable, you can take over. Remember, never tickle a child's face; it can irritate their eyes and it usually makes them blink.

Children under one-year-old may lean away and topple over, so always keep Mom or Dad close just in case. The tummy is the best place to start using the tickler on most kids. With infants, I recommend a slow touch of the toe to gauge the reaction. It may take several attempts before your subject reacts with a full smile. However, once you win their trust, the tickler becomes your best friend.

One of our favorite ways of using the tickler is playing the roar game. My assistant will tell the child that she is coming to get them. I will then tell them to roar and scare her away. As she approaches with the tickle the kids roar and she runs back to the camera acting frightened. This game is hilarious and works every time!

The Treat Box. There truly is a fine art to bribery. One of the most important rules is never promise a treat until you need to. Within three minutes of a child entering my studio, I determine the way I will bribe him. If he is in a great mood, I don't mention any rewards. If he is upset or shy, I start talking about the *big* treat box I have. I ask a question like, "What color sucker are you going to pick, red or blue?" If I need to, I point to the very large candy box. That always sparks their attention.

Throughout the session, I make reference to the treat box, telling them that if they are good, they will get one, two, or three treats. I make a big deal out of the fact that nobody ever makes it to three. I also tell them that I bet they could do it. During the session, I says things like, "Okay, you are up to one-and-a-half treats." I also tell them that if they get a half treat, I get to eat the other half—and this will be gross, because I get the first bite. This always makes them laugh and it keeps their attention.

Finally, during the last shot, I grab a handful of candy, hold it up and say, "Okay. Say, 'Please!'" That always guarantees that the last shot captures a great smile!

I use this technique as long as it keeps their interest. If I think I am losing them, I walk over to the treat box and select a packet of Smarties. They now watch with renewed interest. I keep the treat in my hand, letting them see it as I work. I may even open it and give a few bonus pieces for good behavior. (*Note:* Some older children will

turn down the bonus treat, because they think it will take away from the ones they can pick later. Make sure they understand that they still get to pick their own treats at the end of the session.)

My treat box is full of lollipops, Smarties, and Tootsie Rolls. Smarties are used during the session because they are quick to eat and don't stain the tongue. Lollipops are only given at the end of the session. If you give one out, or even let a young subject see it, you may lose the whole session. In addition, I have a box of stickers for children who can't have candy. I also keep giant jars of goldfish crackers, animal crackers, and a big jar of "cool candies" that the older, more stubborn children can be bribed with.

The Rubber Chicken. When I was in grade school, our school photographer was known as the Chicken Man. He would sit a child on the stool to shoot their headshot, then go behind the camera, pick up his rubber chicken and say, "Don't hit me, Mr. Chicken!" Then he would

A rubber chicken can bring smiles to a lot of kids' faces.

smack his head with the chicken. This silly antic worked time and time again. I was always determined not to smile at this goofy man, but no matter how hard I tried, I could not contain my smile.

About four years ago, I was in the mall with my oldest daughter. Out of the corner of my eye, I saw a rubber chicken hanging in a store and was quickly reminded of the Chicken Man. I felt I had to add this silly prop to my repertoire, so I purchased several of these chickens and brought them back to the studio.

To make a long story short, this goofy toy has saved my neck a million times. Its ugly face and loud squawk can settle many wild children. It can also be used to startle a busy toddler. To do this, I stay farther away and make just a little noise. The toddler will usually become very serious and stop moving, allowing me to capture a soft and serious look that can be hard to come by when working with a rambunctious tot. In fact, more often than not, the chicken scares the child just enough to settle him down. Older children think the chicken is hilarious. With little boys, we use it to play a toss-the-chicken game. Our chicken has even made it into a number of family portraits and is always a way to get a serious dad to smile.

Our rubber chicken is such a hit, he's actually made it into a number of portraits.

Word Games. For toddlers, animal or counting games are a great way to get the excitement going. Asking a child what a particular animal says can get them smiling. However, if you repeat it back to them incorrectly they will really crack up. I will also whisper to Mom to play along when I play the number guessing game. If I hold up two fingers, she will guess that it is four. We then tease Mom when the child gets it right.

Funny Phrases. There are always a few phrases that I reserve until I have to use them to help evoke those great smiles. A few of my favorites are: "Okay, everyone. Look right here and say 'Mommy is a monkey!'" Another favorite is "Daddy wears diapers!"

Now be prepared when you say either of those phrases—the kids will laugh and smile, but they will also turn and look at their mom or dad to confirm the fun. I am prepared for this and as soon as they turn, I say, "Hey, your mom isn't a monkey, is she?" Or, "Your daddy doesn't wear diapers, does he?" This will bring their eyes back to me for the shot.

In addition, I have many words I use to keep the child's attention or get their mouths smiling in unison. Some of these phrases include: "Say, 'Yes.'" *Yes* has a way of getting a nice soft expression. Instructing the child to say "yeee-haww!" always brings a smile. A few others that work are, "Ooh-la-la" and "hubba-hubba." For older children, you can ask them to say "I'm gorgeous!" or "I'm *so* good looking!" The cute embarrassed smile is always a winner. When I am near the end of a session I might have them all shout "Are we done yet?" or "Candy, please!" This always works!

Of course, I never use words or phrases that are inappropriate. I have heard photographers say phrases like "I'm sexy" or "I'm hot." Personally, I feel that this is inappropriate even for older children. I also avoid saying things like "Move your butt over here." Instead, I say "Move your bottom." I just do not feel a parent really wants us to help their children learn gross or vulgar words—even if it is just to be silly.

When dealing with adolescents, avoid teasing them about the opposite sex. I have heard photographers ask kids about their boy- or girlfriends. Pre-teens get embarrassed easily, and most are very self-conscious about the changes their bodies are going through. Add that to their awareness of the opposite sex and you can really embarrass or upset them. I have found that working with the positives, like complimenting a girl's beautiful eyes or a young man's handsome smile, is the best way to go. Everyone enjoys a compliment. If you build on the positive attributes, you can have any pre-teen ready to model in no time.

Balls and Toys. When using balls and toys to evoke a smile, you must be very careful; younger children may not want to give the toy back. If that happens, you may be stuck digitally removing the toy later. A great way to create a relationship with a young child is to have the toddler throw the ball to you—or get him to throw it at your feet to make you dance around. Remember, the child's eyes will follow the ball, so when you catch the ball, be sure to hold it right above the camera.

Many times, a child will enter the camera room with a small toy or stuffed animal in their hand. Parents will often say, "It's okay if she holds that." Unfortunately, I know it is definitely not okay for that toy to be in the image. You cannot create a beautiful wall portrait if Thomas the Tank Engine is in your subject's hand. Retouching it out later is a difficult and time-consuming process as well. I will try several techniques, including bribery, to get the toy out of the shot.

Give Me Five. This popular game works every time. When I ask a child to give me five, they slap my hand and I bounce back to the camera saying, "Ouch! Ouch! Ouch!" Once they realize that you are playing, they will try harder to get you to cry. With sibling groups, I take turns, starting with the oldest child, then running back crying when the youngest child gets me.

Hiding Snacks. If you are looking for a subtle expression, consider hiding a snack within an object. If you insert a treat in an open book or inside a flower or prop, your subject is sure to stop and look for it. This will create a thoughtful and serious look as the child focuses on

My emergency kit.

the task at hand. These images become timeless treasures, and often the final wall portrait.

Emergency Kit

Although I'm sure you all have a version of an emergency kit, I thought I would give you my list. The important thing to remember is that these items must be kept in a convenient place. We have a simple red toolbox that holds all of the items. We keep one in each work truck and one in each studio. I also keep the list of items laminated and adhere it to the inside of the box. It is regularly stocked.

bobby pins	eyeglass repair kit	fishing line	hand lotion
hair spray	two large clamps	velcro	water bottle
hair elastics	two small clamps	lip balm	flashlight
combs	duct tape	scissors	small tissue
brush	Band Aids	first aid kit	allen wrenches
safety pins	insect repellent	AA batteries	plastic zipper bags
mirror	pens and pencils	super glue	nail clippers
tiny screw drivers	water spray bottle	lint brush	nail file
pocket knife	sewing kit	aspirin/pain reliever	gloves
		black sharpies	hand sanitizer
		baby wipes	bubbles
		black/white shoe polish	squeaky toy
		rubber bands	pliers
		string or twine	lens cleaning cloth
		lens cleaning solution	canned air
		cable release	glue gun
		skin lotion	cotton swabs
		grey card	nail polish remover
		sunscreen	shower cap
		calamine lotion	dog treats
		bungie cord	

Celebrating the milestones in a child's life with professional portraits creates a memorable photo essay of the child's development and allows you to develop a lifelong relationship with the family. There is no greater compliment than to realize that the young person having their senior portraits done was once nestled snug in your baby basket. How many other jobs offer that?

By building repeat business, you also boost your bottom line. This can be further enhanced by tailoring a few add-on products to offer with each age group. Your goal in any session should not only be to create a wall portrait and several gift products, but also to find ways to educate your clients on the many different options offered. This gives clients reasons to come more often and helps you separate yourself from other studios. Unique products also keep your look fresh.

The following are some tips for photographing each stage in a child's development—and some add-on products I suggest you consider marketing in addition to your usual prints.

Maternity Session

Often a client will contact us early in their pregnancy and set up a maternity session. These sessions are fun because the client usually trusts us to create anything we want. When a pregnant mother first enters the studio, I will discuss clothing with her. I will view her clothing suggestions and recommend a few of my own. Then, I generally start with the safety shots. These are the images where Mom is fully clothed—shots she can show to friends and family. After that, the session can become more intimate depending on Mom's comfort zone. This could include photographing her in everything from a tube top or tank top to fabric wraps. If she is interested, we may even provide a complete nude study. These images are very personal and are some of my favorite to create. You will find that when you work with a pregnant mother, you are likely to become the family photographer for life.

Mother and Infant Session

There is nothing more precious than an infant next to her mother's warm skin. These types of images not only touch on the core of being a mother, they also capture

Mother and infant sessions touch on the core of motherhood and capture a time that passes all too quickly.

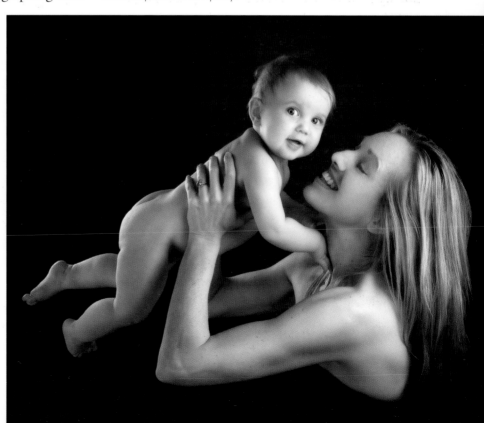

those fleeting moments of a newborn's first few weeks. This time is magical and it passes so quickly.

When a new mother enters my studio, I know that there is a 99 percent chance she will end up in some, if not all, of the images. During the consultation, our portrait consultant explains the importance of these images to the new mom. We suggest that she come prepared to be in them, and whenever possible, bring Dad, too. I know that the images created with Mom and Dad involved will have more value.

> ## "Precious baby, you come to me from where love is infinite, where angels speak a language only babies understand." –*Aida Ganddini*

When addressing the issue of clothing, my clients are given three choices. They are welcome to stay in the clothing they are wearing, they can wear the provided black mock turtlenecks, or they can take skin-on-skin portraits. I explain that skin-on-skin portraits are the strongest of the three choices and that a tube top will be provided for Mom if she would like to choose this option. Most parents will look to me for guidance.

I try very hard to convince them that the clothes they wore to the studio are inappropriate because of distracting lines and patterns. I work extra hard to convince them that the black turtlenecks command the focus of attention to the baby and the skin tones, thus making the entire image about the relationship they share with their new little one. Finally, I reiterate that the skin-on-skin look is by far the best choice. This eliminates all distractions and lines and takes this new relationship to the next level.

I also have a studio full of wall portraits that illustrate the difference between clothing-on and bare-skin images. This allows me to show clients the power of an image that focuses on nothing but the moment.

Keep in mind that this is a sensitive time for the new mom. As the mother of four children, I can testify that I would not be eager to be photographed anytime during the first six months after giving birth. It can be an uncomfortable and frustrating time, and emotions can run all over the place. It's important to assure Mom that her fears and concerns about her post-partum body are understood. Let her know that you would not photograph anything she would not like to hang on her walls at home. When that is explained, you can see mom relax; this makes sense to her. It is very important to say you will not photograph unflattering poses—and to make sure that you don't show any unflattering images at the presentation.

Look for angles, poses, and lighting setups that will showcase the relationship between the parent and child and without highlighting leftover baby weight. The best way to get this knowledge is to practice. Offer free or discounted sessions to friends and family. Try different poses and lighting scenarios until you find the perfect combinations. Once you have mastered these skills, your paying clients will appreciate your efforts and your sales will be the proof that it was well worth your time.

Infants (Up to Six Weeks)
The Session. This is a wonderful time to create what we call relationship portraits. As much as parents love images with their child's eyes open, newborns sleep a lot. Encourage parents to be a part of the session, explaining that this provides the strongest image. A relationship portrait literally brings tears to the viewer's eye.

Brag books are a great product for proud moms, making it easy to show off all of her images.

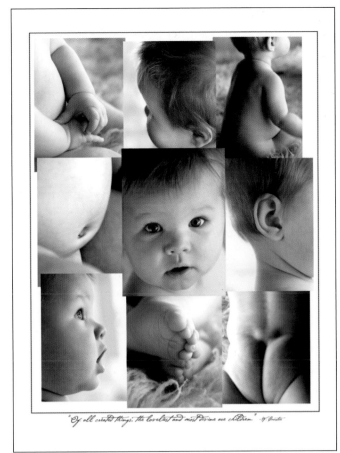

Our nine-up collections showcase some of the baby's cutest features.

These tender portraits provide especially precious images for first-time parents, but it is often difficult for them to relax and enjoy the moment. They are still new when it comes to handling these little bundles, so allow a little extra time. In addition to allowing time for your client to relax, don't forget about feedings. Within an hour session, the baby will inevitably get hungry. Make sure you have a comfortable and private area for the mother to nurse—she will really appreciate the kindness. Also, offer her a bottle of water. The first few weeks after giving birth are emotionally and physically draining. Extending this little courtesy will go along way in creating a bonded, loyal relationship with your client.

And don't forget to prepare your client for the possibility that they might get wet. Infants are like mini-machine guns, constantly projecting something from one end or the other. I assure the parents that we do a ton of laundry each day and that I feel bad if my studio *doesn't* get the child's blessing. They laugh and are less uncomfortable when the inevitable happens. Have wipes, cleaning supplies, and paper towels ready—and don't just stand there, help with the cleanup! It's not fun, but it demonstrates compassion and makes your clients feel like you are a superhero.

Product Suggestions:

Brag Book—A small 3x3-inch book of ten images showcasing the baby's many features and body parts.

Image Folio/Frame—A series of images showcasing the relationship between parent and child.

Nine-Up Collection—Nine tight images of the baby combined into one art piece. This is the most popular infant product and almost always sells.

Three Months

The Session. At three months, the child has usually been smiling for several weeks. He recognizes Mom's voice and responds to her cooing. I really prefer the baby to look like a newborn at this stage. Poses that work best include a basket shot, with baby nestled in his own blankets, and the traditional tummy shot. For most clients, this is their first session, so I always try to include the parents for some relationship portraits—especially if they missed the three-to-six week session. Also, doing little vignettes of the baby's hands, feet, tummy, and a tight close up of the face ensure an add-on sale that Mom cannot live without. We always showcase these images as a complete framed set.

The best attention-grabbers for children of this age are small rattles, black and white baby toys, and Mom's voice. Try to get the baby to look into your eyes. Once you have their attention, do not look away. Speak softly to them using their name. Use words like *sweetheart* and *baby* that are commonly used by the parents. Try short sentences

A three-panel frame showing the baby's hands, feet, and face is an ideal product for this age group.

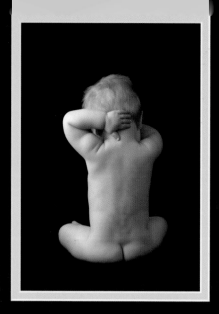

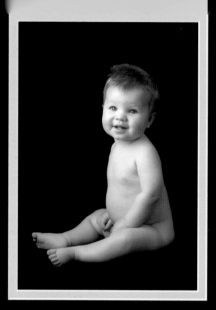

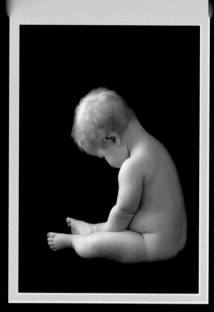

like "Who's the sweetest baby?" with a really soft voice, keeping your eyes fixed on the baby.

Product Suggestions

Baby Panel—A three-image frame showcasing the baby's hands, feet, and face.

Image Box—A box that hold six to ten matted prints that can be rotated on an easel for viewing.

Watercolor Notecards—Simple notecards that can be printed in-house. These are great thank-you cards/birth announcements.

Six to Seven Months

The Session. We educate our clients that the portrait session will be best if their child is sitting up. This usually happens between six and seven months of age. If the child is not sitting, the images will be very similar to the three-month portrait—but once a child can sit up, the posing options expand. Now you can use age-appropriate props that reflect a child's interests. You can bring personality into your images by posing little boys with a sailboat or blocks and little girls with flower wreaths and beads.

Also, the classic nude shot is a must. A baby sitting bare on a blanket, or photographed from above, creates a fantastic image. While taking portraits of naked children, always remind parents to turn the baby away from the

camera, and be discreet in what is photographed. I joke that I like naked images, but I don't want to go to jail for them! This always makes parents laugh and lets them know that I, too, am a concerned and caring parent.

By six to seven months, babies respond to a feather tickler with giggles. They love games like peek-a-boo, and pretending to sneeze will usually make them laugh. This is also the age at which children start to have stranger anxiety. If a child is clingy, sit on the floor and keep your distance while Mom holds the baby. Start to play little games like peek-a-boo while maintaining the child's attention. Mom can slowly inch away from the baby, and soon the baby will forget Mom. Explain to Mom that it's important that she doesn't push the baby away from her to get the image. This can cause the child to panic and

will make the session much harder. Tell her that anytime her baby needs a hug, she should stop and give one. This assures the little one that everything is okay. Many times a child may cry, but by using simple toys or bite-size crackers, you can win back their attention.

Product Suggestions

Brag Jewelry—Bracelets and charms that showcase a baby are great sellers. In addition to Mom, Grandma will also proudly display her portrait charms. This is a great advertisement for you too.

Portrait Handbag—A portrait handbag is a great way for Mom to show of her little one and it really grabs attention when she is out running errands.

Portrait handbags show off your work while Mom runs errands.

As children approach their first birthday, a great portrait opportunity arises when they have learned to stand but can't quite walk yet.

One Year

The Session. First-year portraits are an important milestone for parents. They have survived the mental stress of sleepless nights, bottles, and diaper changes that go along with parenting an infant. They have seen rapid developmental changes that were exciting and which foreshadow a more independent future.

The perfect time to photograph the child is as soon as he can stand but before he can really walk. The ideal session would be with the toddler stepping forward with one foot off the ground—but good luck scheduling that! It is a good idea to have several props for the child to lean against. I prefer a vintage look to a modern one; antique strollers, tricycles, and chairs have a more traditional look that a plain block. This is also a good time to try outdoor photography. A little girl having a tea party or a little boy fishing make excellent portraits—images that will generally command a much higher sale than a session in the studio. During the first-year series, I suggest trying to

A "destruction of birthday cake" series is classic for one-year-olds.

photograph at least three different backgrounds per session. This will give your sales associates plenty of options to create unique sales opportunities.

This is also the perfect time to do a series session. The simple destruction-of-a-birthday cake series will add another product to raise your profits—in fact, this session is so popular that I am now a certified cake cleaner! Before you decide that this session is too messy, keep in mind that this is an add-on sale. In addition to a package, any client who makes the effort to bring in a cake will definitely add a framed version to their sale. This can add $300 to $500 to the sale, which is not a bad deal for a five-minute clean-up. Of course, in addition to cleaning up the cake, you will need to provide a place to clean the baby. We have a large kitchen -type sink in the bathroom where Mom can bathe her little one. We also provide washcloths, infant soaps, towels, and diapers. These are the little things that clients really notice. Be sure to clean the bathroom before and after the session.

The first-year session is also a great time to mention a future family portrait. The toddler now looks much as he will as he grows older. You may even want to offer a free family sitting for a portrait taken before the child's second birthday. Family portraits account for our biggest sales averages, and we want our clients to start the tradition early so it becomes a habit. Many of our yearly sessions were originally baby's first-year sessions that turned new customers into loyal clients.

Product Suggestions

Birthday Series Panel—Four 5x7-inch prints in a custom frame.

First Year Series—A baby program will allow you to show the full year growth and include a three, six, and one-year portrait.

Eighteen Months to Two Years

The Session. I believe that eighteen-month- to two-year-olds are some of the hardest kids to photograph, but these sessions can also be the most rewarding. At this age, the child understands what he wants but cannot communicate it very well. This can be frustrating for both the toddler and the photographer. The best defense is to keep them so fascinated with your tricks of the trade that they forget to be demanding.

You must be prepared to think fast. Change your techniques often to keep the child guessing. Switch your tone of voice, change toys, and move around to keep the child engaged. Also, expect to spend less time in this session. Most little one's attention spans are short. Once they are bored with you, they can easily get frustrated. Therefore, I keep the poses simple and prefer to take my sessions outdoors whenever possible. That way, when the subject get bored, I can still create wonderful candid shots.

Some of the best images at this stage are created when the child it busy doing something. A little girl looking at a flower and a boy playing with a pull toy are classics. Keep in mind that they will not just stand there and hold

the prop. Tell them to look for the ladybug or hide a piece of candy in the toy to keep their interest. Don't expect perfection, just let the child relax and you will be pleased with the outcome. When a toddler gazes up at you and you capture that soft little look, you are sure to melt the hearts of her parents.

Product Suggestions

Essence—A framed print that shows four different view of the child's face.

Our Essence print shows four different views of the child's face.

Three to Four Years

The Session. This is my all-time favorite age. Three-year-olds are old enough to communicate verbally and are usually willing and excited to participate. They are full of energy and generally like to make people happy, yet they still have a toddler look with chubby cheeks, tiny teeth, and pudgy hands. This makes it an excellent time to create a timeless portrait.

We use storytelling props to help create reasons for your clients to visit your studio more often. Our fairy,

Georgia

Sandy Puc' 2001

ABOVE—*Three- and four-year-olds love to make faces. We capture them in a memorable collection moms love.* FACING PAGE—*When a child is five to six years old, it's a good time for a classic formal portrait.*

baseball, fishing, and little ballerina sets are just some of the many storybook sets that we offer for kids in the age range. In addition to suggesting storybook props, we encourage our clients to bring things that are special to the toddler. At this age, children are just starting to use their imagination. Watching them get excited over the props and sets makes the job even more fun.

The best part about, working with this age is the ability to use bribery. Most three- to four-year-olds are very familiar with candy. Using simple snacks like Smarties and lollipops can really keep the session going.

Product Suggestions
Making Faces—A collection of images showing personality shots.

Five to Six Years
The Session. A huge turning point in a child's growth occurs at ages five to six. Most children are just starting to lose their teeth. The last little bits of chubbiness disappear, marking their transition from toddler to child. They are very interested in what you are doing and generally will participate willingly. This is also the time when subjects start to make forced smiles. Remember, parents have been telling their child from an early age to "Say, 'Cheese!'"—which elicits a "cheesy" smile. The child has used this as the model for what they think their parents want to see. Of course, that expression is exactly what the

parents *don't* want them to look like, even though they themselves taught them to do it! The best way to avoid seeing a fake smile is to keep the child talking. Have them repeat short sentences that are sure to make them giggle. "Mommy is a monkey" and "Daddy wears diapers" are giggle gold mines. I also ask them if they have brushed their teeth today, then pick up my feather tickler and threaten to clean them myself. Acting silly is totally okay.

Product Suggestions
Eclectic—This 4x10-inch image displays three different poses, usually a full-length, a three-quarter-length, and a really tight headshot. Normally, only one of the images has the child looking at the camera.

Oil Portrait—This is a great time to create an heirloom portrait. These oil paintings are created digitally and have an old-world look and feel.

Seven to Twelve Years
The Session. I call this the "scary teeth age." In additions to thinner faces and longer bodies, most children have lost several teeth and the insides of their mouths look like the Manhattan skyline. If you press for a smile, you may run the risk of having Bugs Bunny grinning back at you. This is a great time to focus on the less smiley, more serious and thoughtful sessions. Try a more traditional pose and stay away from tight close-ups.

Product Suggestions

Emotions—This montage of several images is a great way to show the child's interest in sports, hobbies, etc. It includes three to six images and focuses on movement. To create impact, usually only one of the images has the child looking into the camera.

Early Teen Years

At this age, children's bodies are going through major changes. Somewhere between dealing with braces and first acne, these awkward young adults long for someone to listen to them and fill them with confidence. Often, I can bring an indifferent or nervous child out of their shell just by mentioning one of their attractive features. Telling a child that she has beautiful eyes or pretty hair can light a little spark of life to a young girl's eyes. A little attention goes a long way. You also can also capture a sweet reaction by mentioning a boy's attributes. Don't go overboard, though—a simple mention is more than enough to crack a smile.

With boys, you may also want to try skipping the compliments; harass Mom a little bit instead. I often send Mom down the hall to get a water bottle, giving me a chance to tell the young man that if his mom licks her hand and fixes his hair one more time I will have the hair police remove her. This always creates a bond that the photographer and subject share—and I get a perfect smile.

Keep in mind that, unlike girls, boys at this age do not respond as favorably to the mention of the opposite sex. In addition to a sour face, you may lose all of the trust that you have earned.

Seniors want portraits that show their unique personality, so the sessions can be very creative.

Product Suggestions

Element—A high-contrast image that brings out the powerful look a pre-teen has. These art prints sell very well.

Senior Portraits

Seniors are still children at heart. They are in the final stages of letting go of their youth and moving into adulthood. This is an exciting and emotional time for these young people. As portrait artists, it is our job to help capture these last moments before they are gone.

Seniors come in all shapes and sizes, and with dispositions ranging from superstar to wallflower. Their clothing preferences, skin conditions, and overall attitude towards having their portraits taken can also affect the final outcome. These challenges make senior portrait sessions very unique. You never know what you will get next.

Even though I will always consider myself young, I don't try to act like I'm still a teenager. The last thing you want to do is try to look or act like these young people. As soon as you think you know exactly what is cool or what is in, they will be onto a new trend and you will be left looking like a goof. So let them set the stage by bringing a range of clothing, accessories, and a selection of their favorite music. Having a place to connect their MP3 player into your sound system is a great idea.

Our style of senior portraiture tends to be a little edgy, and we like to push the limits when we create. Therefore, we cater to the kids who like to show personality and a bit of attitude. The students know their investment will provide a unique session that is custom fit to their look and personality. We are totally dedicated to making them look like a star.

This does not, of course, mean that we use inappropriate poses and sexy clothing during the session. If I feel that a pose is too sexy, I will not shoot it. If I feel that an outfit is a bit too revealing, I will find a creative way to suggest that we do not use it. I know many photographers might disagree with my attitude. However, my personal opinion is that if it would make me uncomfortable if my own son or daughter were wearing it, I am not going to use it.

10. Special Sessions

Group Portraits

If you put a little planning into it, working with more than one child can be both fun and rewarding. Brothers and sisters share a special bond, and it is your job to capture it. Regardless of the age difference, children really love their siblings and enjoy having fun with them.

Sisters. Little girls are always a delight to work with. Creating timeless images is quite easy if you have taken the time to prepare your concept. So many posing and prop ideas can be used: having a tea party, reading a book, playing dress up, or just giggling on the floor.

The special bond that sisters share is a treasure to behold. When working with them, I try to use the older sibling as the assistant. She may be tying the ballet slipper or reading a book to her younger companion. These images show the connection that the girls share, and they can be very emotional for the parents to view. These tender moments are just the way Mom and Dad want to remember their little girls.

Brothers. Little boys are also lots of fun. Their adventurous attitudes and eagerness to play are great tools when creating an image. Anything that is interactive and involves nature, construction, or playing in water will grab their attention and make a winning image easy to capture.

When posing brothers, I often use the bigger brother as an anchor. I'll put him in a sitting position

Sisters share a special bond that is always fun to capture.

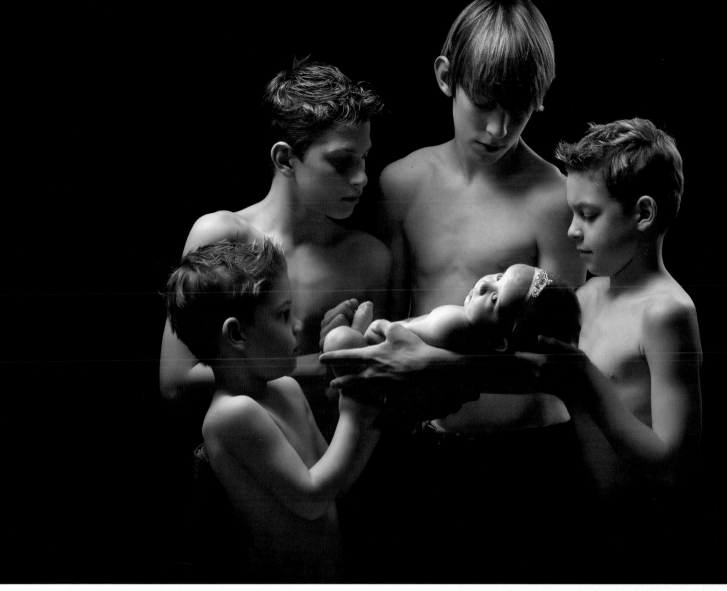

Here, the big brother, holding their new little sister, is the anchor for the portrait. The other brother are arranged around him, helping to hold the baby.

and have the younger sibling standing. Many of the images I create are interactive and show that boys will be boys. Once I have my safety shot, I will often finish the session with a little wrestling match or some splashing in the water. These images are great in a frame series and can be a hoot to create. Just keep everything under control; it only takes seconds for things to get too rough.

Age Gaps. One of the first challenges I faced when I started photography was dealing with siblings that had large age gaps. Photographing a sixteen-year-old with their three-year-old sibling can really pose a challenge when it comes to creating a timeless look. Ultimately, your goal is to get the older sibling to look less dominant and have the younger sibling not look too small.

Twins, Triplets, and More. One of my favorite challenges is working with multiples. I know that when Mom and Dad arrive, their expectations are simply that I get the kids in the image together. By preparing ahead, though, I can provide them with a wonderful portrait they are thrilled to own. After so many years in the profession, I have worked with every combination—twins, triplets, quints, and quads. Each group brings its own mix of fun. Your biggest weapon is patience. Understand that things are going to be fast and crazy. Know the poses you will suggest and have everything ready to go.

Infants. Posing infant multiples can be a very rewarding challenge—there is something really magical about them. However, you must have a lot of patience and

allow extra time to ensure that you can capture the images the parents expect. Often, just as you get one infant happy, the other will start to cry. Allow ample time for feedings, burping, and diaper changes; they will definitely be a part of the session. (*Note:* This is an overwhelming and emotional time for the parents, so don't be surprised if tears flow when you present those first images at your image presentation.)

Toddlers. This is where you really earn your badge of courage. Having multiple toddlers in your studio can be an exhausting effort. Thinking of all the chaos I have seen over the years when we create these sessions just makes me laugh—the vision of adults chasing babies left and right while I try to capture the moment must truly be a sight to behold. As you can imagine from that description, the poses that work best tend to be interactive. I also understand the power of the Photoshop head swap and I know how to use it!

Children. After the toddler years are finished, I find that multiples tend to be very well behaved. I have had many quints and quads march in the studio and do just about anything I ask. My best guess is that being raised in a group scenario teaches patience to both the children and the parents. Some children will arrive in matching outfits; others like to show their independence and may be dressed in an eclectic mix.

Teens. By the time they are teens, many of the multiples I have worked with are looking to define their own identities. They may have different haircuts, attitudes, or choose to wear different clothing to show their independence. Capturing these differences are important, but the relationship between the children should be apparent, as well. I have seen everything from tender and affectionate siblings to very independent siblings.

Kids with Special Needs

Many times during your career you may be asked to work with children who have special needs. These children are loved dearly and, regardless of the challenges, your goal should be to create an heirloom image that the parents will treasure forever.

One of the biggest hurdles when approaching this subject is understanding exactly what the child's needs or difficulties might be. The best resources to answer these questions are the parents. You may feel uncomfortable asking questions about the child, but most parents appreciate your efforts and willingly offer advice or assistance on ways to make the session run smoothly. It is best to ask these questions during the initial client consultation. If possible, do a little research about the child's condition before the parents arrive, so you will have a better understanding of what questions to ask. (*Note:* A wonderful resource for photographers is the Picture ME Foundation, an organization was founded to train photographers who want to provide better service to parents with children who have special needs.)

When working with children with special needs, be sure to allow extra time. You want to make sure that you

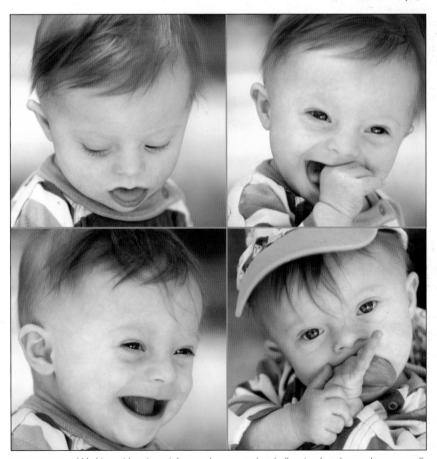

FACING PAGE—*Working with twins, triplets, and more can be challenging, but the results are usually rewarding.* ABOVE—*When planning a session with a child who has special needs, check with the parents for advice on making the shoot safe and fun for your subject.*

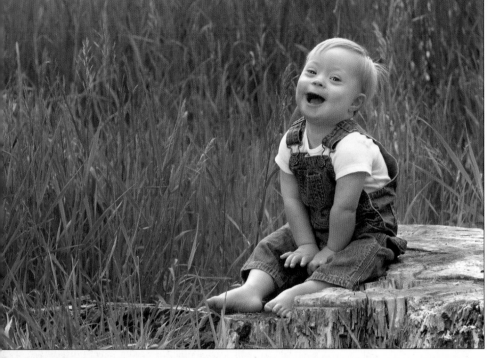

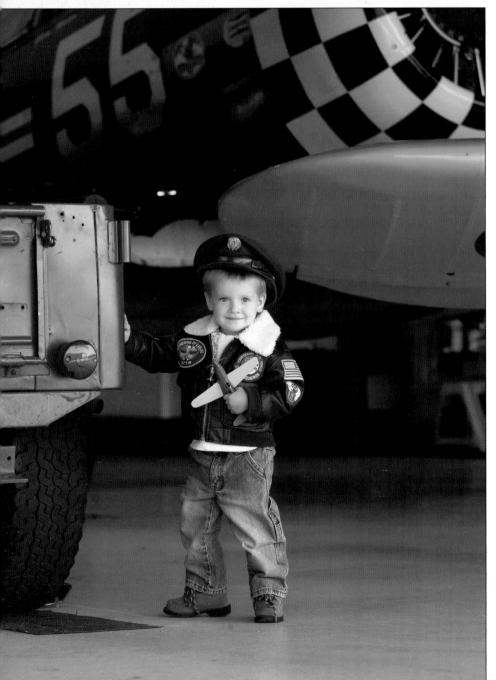

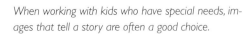
are not in a hurry and that the parents feel comfortable and not rushed. Often, the parents are your best resources for coaxing a smile. They may have a special song or game, or perhaps a toy that works like magic. As a team, you will definitely capture something special.

While creating your poses, sometimes it's best to create an image that tells a story. This could be a shot of the child playing with blocks, looking at a book, or interacting with a sibling—often the most endearing images are of siblings hugging or smiling at each other. Keep your posing less formal and just let the session evolve. With a little love and a lot of patience, you will provide a wonderful session and a treasured portrait.

The following a list of some of the conditions that you may encounter when working with children.

Attention Deficit Disorder (ADD). This condition is hard to deal with, because parents may not mention it at the consultation. A child with ADD can be distracted easily. They may be very hyperactive or restless and unable to focus on anything for more than a few minutes. To prepare for this session, have many interesting toys available. Sometimes a laser pointer or fiber-optic lights are useful attention-getters.

Muscular Dystrophy (MD). MD causes the muscles to grow weak, crippling the arms, legs, and spine. Most children who suffer from this disease will be confined to a wheelchair. Knowing this, you can prepare by having a special chair available that will comfortably hold the child. I have also covered the child's own wheel chair with white fabric for a soft nest-like image.

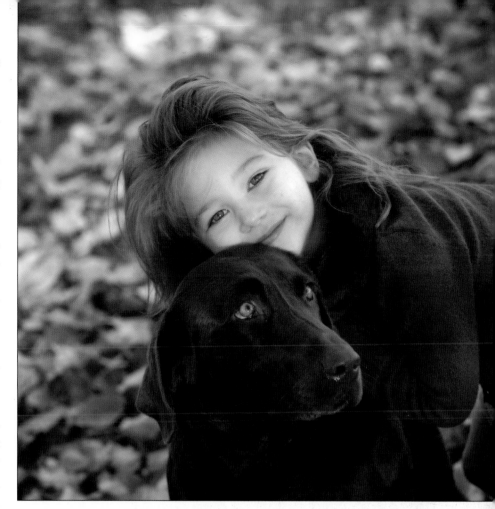

When kids are around their pets, you're sure to see what childhood is really all about.

Autism. Autism is a severe disorder that disrupts communication and behavior. Some autistic children act very withdrawn and may not even be willing to look at you. Others may be very hyperactive. Following direction can be very difficult for these children, so it is best to work on casual poses and try to involve a sibling or parent in the image. Using props like books, blocks, or other small toys may provide a great distraction—but be prepared to shoot quickly. Have your equipment ready and focused so that you do not miss your moment.

Mental Retardation or Down Syndrome. These disorders can cause a range of conditions. The children might be developmentally delayed, or they may need constant care. These children often break into smiles very easily. Games such as peak-a-boo or using a feather tickler work very well—but do everything slowly to avoid scaring the child. Once you capture their attention, you will also capture a wonderful image.

Again, your best option is to research each condition and know what to expect. Talking to Mom and Dad will be a big help, too. Remember, the parents' expectations will be different; they understand the limitations and are grateful when you show a caring heart, an educated mind, and the patience required to create a special portrait.

Kids with Pets

Whenever you combine pets and children you are sure to hear a few laughs! I

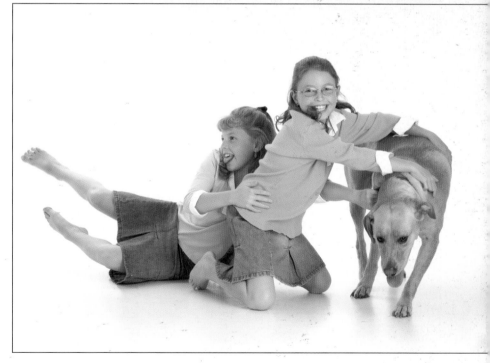

love watching the relationships unfold as children play with their pets. Whether the pet is large or small and whether it has fur, scales, or feathers, you are really going to see the magic of what being a child is all about.

When it comes to pet sessions, though, all rules go out the window. Proper posing rarely comes in handy, because your main goal is just to get all the eyes on you. My biggest suggestion is not to sweat the small stuff—

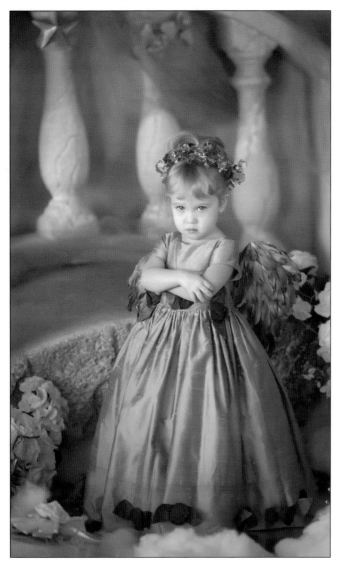

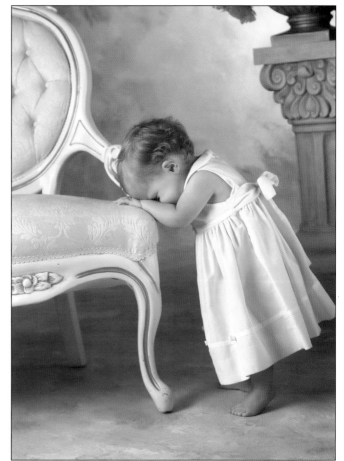

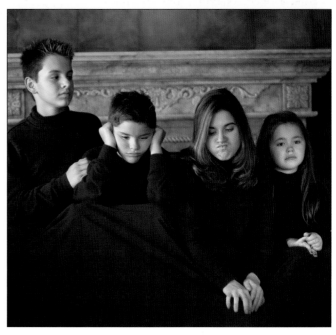

If outtakes are appropriate, leave them in the sales session. Sometimes the parents will buy a small print of the shot just to remember the funny moment. As you can see in the bottom right image, even my own children don't always behave!

just relax. Look for ways to show laughter, movement, and love. Somewhere in the chaos and fun you will capture the perfect moment.

Outtakes

It just wouldn't be right if I didn't share a bit of the humor that happens on a typical day. It gets even better when the moment is captured for everyone to see. From silly faces to the warm and wet gifts a naked infant will bestow, there is always something funny to evoke a smile. As long as they are appropriate, keep these images in the sales session. Mom and Dad will see the humor, too—and don't be surprised if they decide to buy a small portrait to remind them of the moment. I just hope that these funny images don't end up in someone's yearbook someday. I don't think I could afford all of those therapy bills!

In addition to creating timeless images, marketing is truly my passion. I feel I have knack for understanding what a client wants and creating a constant buzz in the community. I would like to share a few important points that will help you start the marketing wheel rolling.

Creating Opportunity

Many photographers overlook opportunities to gain excellent exposure and new clients, as well. Namely, they overlook friends and family. Is there someone you can partner with to provide a fundraiser? A joint marketing campaign? A model search contest? How about a display in their store or a portrait drawing giveaway? Many of your family and friends—and even your clients—have businesses that you could partner with to share client lists and create more success for both of you.

Some of the many marketing ideas that have brought us success are working with realtors, small businesses, and interior designers. We provide a certificate at a reduced price and they provide us with a new client opportunity and additional exposure. Some of our best clients come from these types of relationships. Always look for new opportunities—and if it works, do it again!

Community Exposure

It is important to get your images in as many appropriate places as you can. Whether it is a temporary display at a bank or a permanent display at a specialty children's store, you should pursue opportunities that will bring in the type of client you would like to work with. We have many displays, both temporary and permanent, that serve this purpose.

In addition, we make it a point to send out press releases whenever something important happens. If we win an award, travel for educational purposes, or provide

"**Setting goals** is the first step in turning the invisible into the visible."

–Anthony Robbins

a service to the community, we want potential clients to hear about it—and to see our studio's logo and portraits everywhere.

Displays in local businesses can enhance your exposure in the community.

The Basics

Here are a few essentials that helped generate our growth. There are many more wonderful ideas that can be implemented, but these are the keystones to our success.

Free Session Fees. My first marketing promotion was free session fees. I carried a handful of free session coupons with me and handed them out wherever I went—the grocery store, nursery schools, and parks

Free session fee promotions can be helpful when starting a business.

While this helped to launch my business—I gained plenty of word-of-mouth advertising—it was also a costly campaign. I was getting unqualified clients, and it was costing me $40 per session (the cost of purchasing and processing the two rolls of film used at each session). I needed to sell two 8x10s just to break even.

I was financially able to do this because I had a husband working full-time. So, if you decide to try this tactic, be aware that you will need some sort of support system in place. Having such a significant expenditure per client can potentially hurt your business.

We have now modified this concept, offer free session fees as fundraising opportunities to local schools and charities. This program not only helps our business, but we feel that we contribute to the community we live in as well. It is a win–win for everyone!

Limited Edition Specials. One of my most successful promotions, and one I still use, is my Limited Edition Specials. Limited Edition portrait sessions were created to provide a unique portrait experience. Each scene is custom built to look as realistic as possible and feature vintage costumes. These sessions are only available during specific dates each month, and some of the more popular sessions book six months in advance. Some favorites are our Spring Special, featuring barefoot children in an open wheat field with antique clothing and props, and our Fall Leaves special, with autumn clothed and wagons loaded with leaves and baskets of apples. I also try to offer as many "boy" specials as "girl" specials, and I try to make them as realistic, in a fairytale sense, as possible.

Image Brochure. I always have an image brochure available to detail my monthly Limited Edition Specials. This helps generate interest in promotions that are still several months down the road. My brochure identifies the most popular sessions and helps to give a sense of urgency to parents interested in booking their children for a special session. We are in the image business, so this literature showcases the very best of what we do.

Our image brochure features images from Limited Edition Specials.

Newsletters. Newsletters, when well done, are a great way to keep you in the forefront of your client's minds. My quarterly newsletter includes a personal note from me, spotlights new products, urges families to schedule

portraits, and highlights ongoing specials and upcoming events. This newsletter lets my clients know that I am always available, and reminds them of why it's important to have a family portrait taken. In addition to this constant reminder, a newsletter can help build a personal relationship with your clients.

Our referral program encourages exisiting clients to point their friends and family toward our studio.

Referral Program. One of my favorite and most cost-effective promotions is my referral program. For each new client who books a session, the referring client is rewarded with a free 8x10-inch portrait. A certificate is sent to the referring client right away, because we want the client to know that we appreciate her sharing her opinion of our work with her friends and family. When she receives the certificate from us in the mail, it also serves as a reminder that she too should come back for another session.

Free Wallet Program. With every order that goes out, we order an extra set of eight wallets. These showcase our favorite image from the session and feature our logo, web address, and studio phone number. When the wallets are delivered with the client's order, they come with a nice little reminder about our referral program. These complimentary images are a handy way for your client to share your contact information with their friends and family.

Outdoor Sessions

As discussed in chapter 7, outdoor sessions require their own strategies for planning, shooting, and marketing.

Marketing. When you design an outdoor special for the first time, you must also plan a great marketing campaign to go along with it. Look carefully at your target market and consider creating some kind of special or discounted offer to ensure your success. Give your plan some time to succeed; personal referrals are your best marketing tool and these will be generated as your early clients share their images with friends and family.

Word of mouth can also grow from community visibility, and the best way to ensure that your work is out in the community is by personally putting it there. If only four of your eight available sessions are booked, select a few of your favorite clients and personally call to invite them for a free session and a $100 credit if they will come and be your models. Select clients you know love your work and who usually spend well on your regular sessions. (Invite each client only once to an offer like this; you never want them to feel taken advantage of). After the session, give your guest clients a whole stack of free wallets (with your contact information) to give to their friends—and remind them about your referral program.

This technique is a great way to accomplish several things. You will provide a wonderful session that your clients will be excited to tell their friends about, you will be saturating the market with your work, and you will be getting the important practice you need to improve your photographic skills.

"The **future belongs to those** who prepare for it today." *–Malcom X*

Pricing. I have always been interested in how other photographers price their location work. When I started my business, I researched other studios' pricing to become more aware of what the market would handle.

Right away, I noticed a distinct difference in the way my session fees were structured compared to other studios. Most studios charge more for an outdoor session than an indoor session. Originally, I thought I should do the same, assuming that this must be the standard way to handle those fees. As I considered this, I took a look at my sales averages. I noticed that my clients happily invested an average of three times more on outdoor work

than on a studio session. This was proof that I should keep my sessions fees for indoor an outdoor sessions the same so that clients would not be swayed by a price difference.

> ## "All growth is a leap in the dark, a spontaneous unpremeditated act without the benefit of experience."
>
> –Henry Miller

Look at it from your client's perspective, if she has a choice between a studio session for $50 and an outdoor session for $150, nine times out of ten she will go with the less expensive of the two. Either way, she will get a wonderful portrait and she will feel she has received value for her investment. However, if she chooses the outdoor session, it is very likely that she will ultimately invest more money in the final product, because outdoor location work lends itself better to wall portraiture. That makes it a win–win situation for both client and photographer.

Getting Inspired with the Salsa Box

One of my best tips for success in marketing is the salsa box. About five years ago, I found myself frustrated after I attended seminars. I would diligently gather information, collecting notepads full of ideas, but as soon as I got back home, those notebooks would end up on a shelf and the ideas would never come to fruition.

As I sat one day thumbing through years of notes, I decided that this needed to change. With the help of my employees, we created what is known as "the salsa box." This box is a completely organized way to handle our business and marketing. Each time I attend a conference, I carry lined paper and several colored folders. As I hear something important, I write it down on a single sheet of paper and then file it in the appropriate colored folder.

Red = Hot! Get this done now!
Yellow = Medium. Great idea but will need to
wait until we slow down
Green = Mild. Neat concept, but I doubt I will
get to it.

Having each concept tucked into its own folder makes accomplishing any task easy. As soon as I get back to the studio, I pull out the red files and implement the ideas immediately.

Without those folders, I would not even retain even one tenth of the information I gather at these professional seminars. By carefully organizing my marketing goals, I accomplish so many more of my objectives—and I know that this concept has worked for many other photographers, too. I always smile when I'm on the road and someone mentions that they now have a salsa box!

TOP—*My salsa box helps keep new marketing ideas organized and ready for use.* FACING PAGE—*Outdoor sessions yield bigger sales, so don't let higher session fees dissuade clients from booking them.*

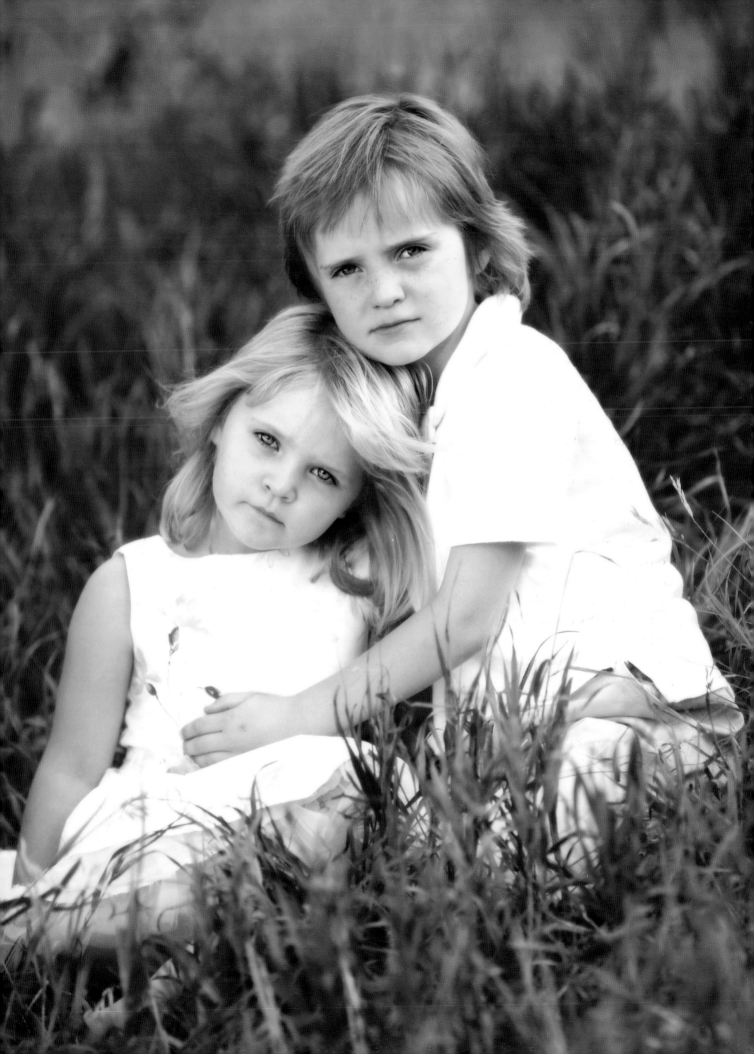

12. Sales

Our sales strategies have changed so much over the years, but our goal never has. We are here to assist our clients in purchasing the unique and timeless images that we provide and educate them on why they should invest their money in our art. We do not try to hard sell our clients; instead we provide quality portraits and art products that sell themselves.

Throughout this book, we have covered many of the different art products that we provide to increase our sales. Long gone are the days when a client only needed a wall portrait and a few smaller images. Today, with all of the new forms of media available, we are selling not just paper, but digital products, albums, CDs, and even the original files. These items are available to our clients, but we charge a premium price.

Creating an Experience

For many years, we sent home a proof book for our clients to view and make their purchasing decisions. I would put so much work into the session, then two weeks later I would send tiny proofs home for my clients to view. Many times, even after collecting a deposit, I would never see those images again. This was a very frustrating and unfulfilling experience for both my clients and myself.

As my studio grew, many of my mentors told me that I could change the inconsistencies of proof sales by going to

projection. At that time, my goal was not to generate more sales. I just wanted more time with my family. I was working six days a week to cover overhead expenses. More than anything, I wanted to go home and be Mom!

Amazingly, from the moment I went to projection, my sales averages almost tripled. The clients were investing so much more because I was providing a complete experience. My only regret? Not listening to my mentors much sooner.

When I made the decision to go to projection, I had no idea what I was doing, so I decided to attend a seminar at Michael Redford's studio in Canonsburg, PA, to see how a successful photographer used projection. Michael graciously took the whole class into one of his luxurious sales rooms where we sat in comfortable over-

Switching to projection proofing tripled my sales averages.

stuffed chairs and were treated just like he treated his clients. Once we were settled, the lights were dimmed, the music started, and a beautiful slide show began. As the images of the lovely little girl faded in and out and the music played, I felt myself moved to tears. I suddenly knew that by changing to projection, I would be providing a complete experience to my client.

As soon as I got home, we redesigned our sales rooms. We created a warm and inviting place where our clients would feel welcome. Everything was considered: the furniture, its placement, the refreshments we served, and the music that would be played. Nothing was left undone.

A Typical Sales Session

When a client arrives, they are offered bottled water with our logo on it and hot, freshly made cookies from our oven. The sales associate greets the client and gives them a basic overview of the process and what they will experience. After everyone is seated, the lights are dimmed, the music is started, and at that moment, the show really begins.

Clients are greeted with bottled water and freshly baked cookies.

Clients view the images on a slow, three-second dissolve. This allows enough time for the viewer to enjoy the images one by one. In addition, we have preselected four to six images to have special artwork on them. These images are marked "artist's favorite," as the photographer personally selects them. Some of the images are made into art products or framed collages. By showing these products, we educate our clients as to the many choices and options that are provided.

Once the slide show is over, the sales associate works with the clients to narrow down the choices by viewing similar poses side by side. Once the images are narrowed to about ten to twelve, the associate assists the client in designing a package. We keep enough images in the favorites so that, in addition to selling a wall portrait and package, we can offer other items such as folios, framed collages, portrait jewelry, purses, and other unique product options.

Bonus Items

At different investment levels, we offer bonus items. These are great incentives to assist in moving a sale to a higher level. I am always surprised at how a client will spend several hundred dollars more to get a "free" item. These bonuses are available in between package prices. For example, if package A is $500 and package B is $800 there might be a bonus available if the client's total is $650. This little incentive works really well. Most clients will just bump the package to the $800 level to ensure that they get the full bonus and package benefits.

Bonus programs encourage clients to spend a bit more to receive premium items.

Bonus structures are also a great way to showcase cool products that clients may not normally invest in. We have several "exclusive" art products that are only available as a bonus. This is another great way to entice your client to

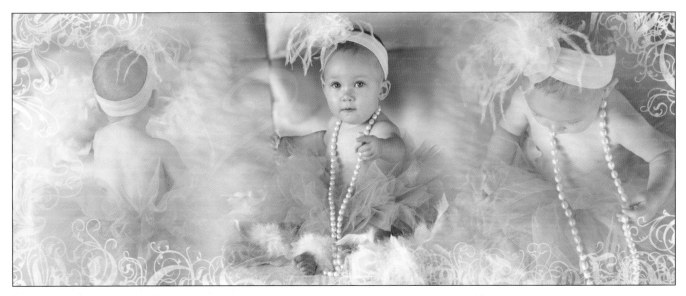

Clients enjoy the many digital art products and framing options we offer.

want to invest more. I really must add that ultimately, I only want my clients to purchase what they really want. It is fun however, to offer unique products. I always feel great when a client thanks me for the enjoyable sales presentation.

Art Products

We have many unique art products available for purchase. These are a mix of digital art and framing options. I found long ago that my clients were really looking for new ways to display their images. As we entered the digital age, we tried many new and creative ideas. While not everything worked, we used this time to improve our skills and now we have a great collection to add to our repertoire.

I would like to add an important thought here as well: We *never* use the word "digital" in anything we sell. It

sounds cheap and unimpressive. We are very careful to talk about *custom* designs, *innovative* products, and *personal* art. "Digital" is what your clients have at home on the kitchen counter for taking snapshots of the kids, not something found in your gallery.

Sales Insight

I am honored that, each day, our sales rooms are filled with laughter and tears of joy. What a fantastic gift it is to be able to watch the delight and excitement as your client views their session (and the fruition of all of your years of hard work). We love working with our clients, we love to see them get involved in the creative process, and we love that they are excited to invest in our work. Having a complete sales system will not only make you a premiere studio, it will also greatly impact your bottom line.

I would be remiss if I did not tell you how grateful I am for the many blessings I enjoy, and I have always made it a point to try and give back to show my appreciation for these blessings. I encourage you to do the same. I'm sure that you will find, as I did, that when you do good things, many good things will happen in return.

Motivations

Pursue opportunities that truly mean something in your life; find causes that have touched you or your family personally, and you will be more successful in your ventures. For example, when my third son was born, he had a serious medical condition. At just six days old, he was rushed to Children's Hospital and we feared the worst. For over a year, we spent time in and out of the hospital searching for answers. Fortunately, the outstanding efforts of the nurses and doctors gave me one of the greatest gifts a mother could receive: time with my little boy.

Accordingly, many of the events and fundraisers that we support are those that benefit Children's Hospital. With much gratitude, it is my sincere goal to help other children who are in the hospital and away from their families. I owe the staff at Children's Hospital the world, and I will never forget their ef-

forts. Every day, I get to see my little boy smile and that helps me remember my debt.

If you are sincere in your motivations (and people can definitely sense when you are not), centering promotions on a charity event will benefit your business in terms of public relations. We have several primary charity sessions that I run yearly in addition to the many donated auction certificates and community fundraising events. The following are two of my favorites.

Halloween Charity

For the Halloween charity event, I transform my studio into a real haunted house, complete with a pumpkin patch for gentler souls. This fun activity has become a

Our Halloween charity event is one of my favorites.

Our Halloween charity drive generates not only cute images (left) but also over a ton of food annually for a local food bank. Additionally, we invite the Children's Hospital Bloodmobile (above) to park in front of the studio during the event.

must-visit for my clients and many other local friends. For a canned food donation, clients receive a 4x5-inch portrait of their children on my haunted-house set. Additional portraits are also available for purchase. This is a fun way to reach out to the community. Since its inception, my Halloween charity has consistently generated over one ton of food annually for a local food bank. We also invite the bloodmobile from Children's Hospital to park in front of the studio and collect blood donations. Our slogan is, "It's time for our annual charity event—and this year we're out for blood!"

Holiday Charity

Our Christmas charity event benefits Children's Hospital of Denver. We create two sets for this session, changing the theme slightly each year, and hire an authentic-looking, naturally bearded Santa Claus. One of the sets is always a traditional scene with Santa wearing his red suit and boots; the other set is a more elaborate, formal set featuring a Victorian theme or an elegant, all-white theme

CELEBRATE
THE
Miracle
OF THE
Moment
YOU LIVE IN.

Our Christmas charity event benefits the Children's Hospital of Denver.

with Santa wearing exquisite, hand-made costumes. It is so much fun to watch children enjoy the magic of Santa as they share with him their holiday wishes.

I am very grateful to Children's Hospital for saving the life of my son, and I hope that we are helping other children in the hospital enjoy another Christmas.

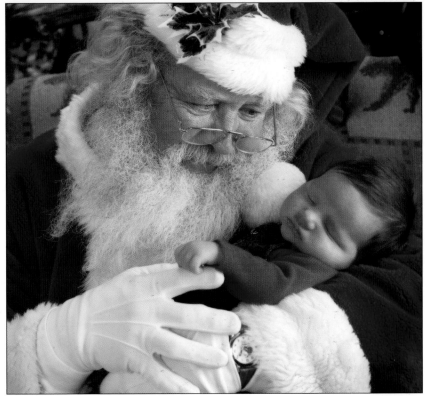

Conclusion

I want to thank you for taking the time to read this book. I hope it has given you a bit of insight into my crazy world as well as some helpful tips that will make working with children more fun and profitable.

For those of you who know me, you understand that I could not finish this book without sharing a bit of per-

Incredible moments abound in children's portrait photography.

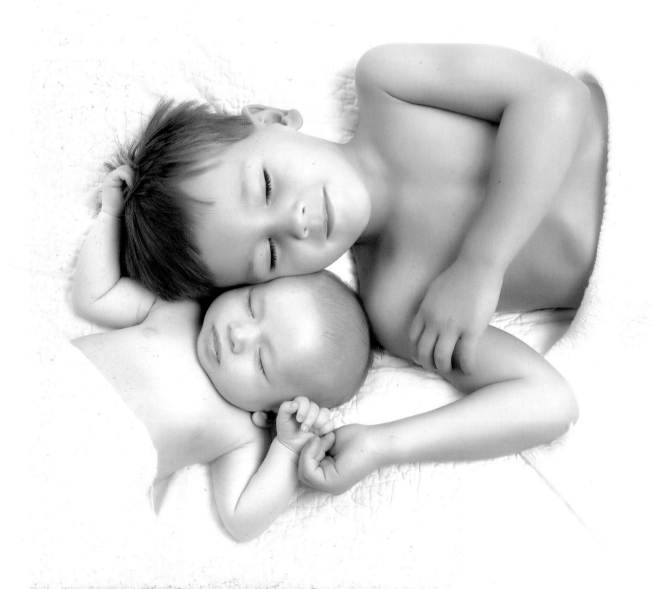

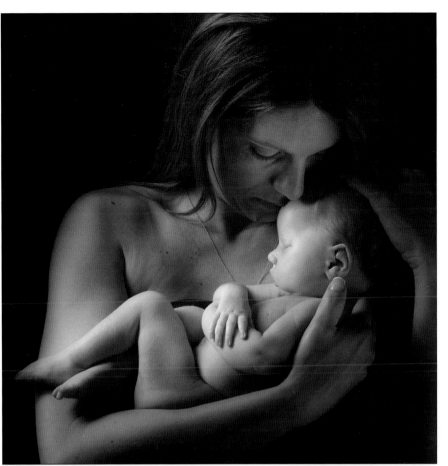

sonal reflection. For those that I may never know, I hope that these next statements will touch your heart and prompt you to find a new outlet for your own gratitude.

There are many ways in this industry to "give back." Being a portrait artist allows you to provide a service that has value to the client, and you may also be capturing the final moments of someone's life. We have all had that phone call when a client asks if we still have the negatives from a certain year. More often than not, they have lost a loved one and are now searching for those priceless treasures.

If you look around at your community with an open heart, you will see many opportunities to share your talents and perhaps benefit a charity or cause.

From the Heart

Before I finish, I would like to share one charity that has literally changed my life. On February 10, 2005, I had the awesome privilege of providing the first and final portraits of Maddux Achilles Haggard. At the time, I had no idea how this little boy would not only impact my life.

A few short months after Maddux passed, his mother, Cheryl Haggard, and I founded Now I Lay Me Down To Sleep. NILMDTS provides portraits to families who have lost or will lose a child. These children are often infants who were never able to leave the hospital. With literally thousands

Now I Lay Me Down To Sleep is a foundation of photographers from around the world who provide free portraits to families who have lost or will lose a child.

of members around the world, our photographers provide a session and all of the retouched images to these bereaved parents. Our photographers provide these services at no charge to the parents or families they serve. These images are literally the final moments of a child's life, and the beautiful portraits provide a lifetime of comfort and healing for the parents, siblings, and friends of these children.

From a very humble beginning when two mothers met and shared one of the most heart-wrenching hours you could imagine, the now worldwide non-profit organization has grown to be so much more than either of us could have imagined. We are both humbled and honored that our original question—What if?— became a reality and a blessing to so many parents.

If you feel that you might be able to provide this much needed service, please visit www.NILMDTS.org for more information.

Again, I thank you for allowing me to share my world, my passion, and my heart. I wish you the best that life has to offer.

Index

OTHER BOOKS FROM

Amherst Media®

MASTER COMPOSITION
GUIDE FOR DIGITAL PHOTOGRAPHERS

Ernst Wildi

Composition can truly make or break an image. Master photographer Ernst Wildi shows you how to analyze your scene or subject and produce the best-possible image. $34.95 list, 8.5x11, 128p, 150 color photos, index, order no. 1817.

THE BEST OF
ADOBE® PHOTOSHOP®

Bill Hurter

Rangefinder editor Bill Hurter calls on the industry's top photographers to share their strategies for using Photoshop to intensify and sculpt their images. $34.95 list, 8.5x11, 128p, 170 color photos, 10 screen shots, index, order no. 1818.

HOW TO CREATE A HIGH PROFIT PHOTOGRAPHY BUSINESS
IN ANY MARKET

James Williams

Whether your studio is in a rural or urban area, you'll learn to identify your ideal client, create the images they want, and watch your financial and artistic dreams spring to life! $34.95 list, 8.5x11, 128p, 200 color photos, index, order no. 1819.

MASTER LIGHTING
TECHNIQUES
FOR OUTDOOR AND LOCATION DIGITAL PORTRAIT PHOTOGRAPHY

Stephen A. Dantzig

Use natural light alone or with flash fill, barebulb, and strobes to shoot perfect portraits all day long. $34.95 list, 8.5x11, 128p, 175 color photos, diagrams, index, order no. 1821.

ADVANCED STUDIO
LIGHTING TECHNIQUES
FOR DIGITAL PORTRAIT PHOTOGRAPHERS

Norman Phillips

Learn to adapt traditional lighting setups to create cutting-edge portraits with a fine-art feel. $34.95 list, 8.5x11, 128p, 126 color photos, diagrams, index, order no. 1822.

THE BEST OF PROFESSIONAL
DIGITAL PHOTOGRAPHY

Bill Hurter

Digital imaging has a stronghold on photography. This book spotlights the methods that today's photographers use to create their best images. $34.95 list, 8.5x11, 128p, 180 color photos, 20 screen shots, index, order no. 1824.

PROFESSIONAL
PORTRAIT LIGHTING
TECHNIQUES AND IMAGES FROM MASTER PHOTOGRAPHERS

Michelle Perkins

Get a behind-the-scenes look at the lighting techniques employed by the world's top portrait photographers. $34.95 list, 8.5x11, 128p, 200 color photos, index, order no. 2000.

DIGITAL PHOTOGRAPHY
BOOT CAMP

Kevin Kubota

Kevin Kubota's popular workshop is now a book! A down-and-dirty, step-by-step course in building a professional photography workflow and creating digital images that sell! $34.95 list, 8.5x11, 128p, 250 color images, index, order no. 1809.

MASTER POSING GUIDE
FOR CHILDREN'S PORTRAIT PHOTOGRAPHY

Norman Phillips

Create perfect portraits of infants, tots, kids, and teens. Includes techniques for standing, sitting, and floor poses for boys and girls, individuals, and groups. $34.95 list, 8.5x11, 128p, 305 color images, order no. 1826.

WEDDING PHOTOGRAPHER'S
HANDBOOK

Bill Hurter

Learn to produce images with technical proficiency and superb, unbridled artistry. Includes images and insights from top industry pros. $34.95 list, 8.5x11, 128p, 180 color photos, 10 screen shots, index, order no. 1827.

RANGEFINDER'S PROFESSIONAL PHOTOGRAPHY

edited by Bill Hurter

Editor Bill Hurter shares over one hundred "recipes" from *Rangefinder's* popular cookbook series, showing you how to shoot, pose, light, and edit fabulous images. $34.95 list, 8.5x11, 128p, 150 color photos, index, order no. 1828.

MASTER GUIDE
FOR PROFESSIONAL PHOTOGRAPHERS

Patrick Rice

Turn your hobby into a thriving profession. This book covers equipment essentials, capture strategies, lighting, posing, digital effects, and more, providing a solid footing for a successful career. $34.95 list, 8.5x11, 128p, 200 color images, order no. 1830.

PROFESSIONAL POSING TECHNIQUES FOR WEDDING AND PORTRAIT PHOTOGRAPHERS

Norman Phillips

Master the techniques you need to pose subjects successfully—whether you are working with men, women, children, or groups. $34.95 list, 8.5x11, 128p, 260 color photos, index, order no. 1810.

HOW TO START AND OPERATE A
DIGITAL PORTRAIT PHOTOGRAPHY STUDIO

Lou Jacobs Jr.

Learn how to build a successful digital portrait photography business—or breathe new life into an existing studio. $39.95 list, 6x9, 224p, 150 color images, index, order no. 1811.

THE BEST OF FAMILY PORTRAIT PHOTOGRAPHY

Bill Hurter

Acclaimed photographers reveal the secrets behind their most successful family portraits. Packed with award-winning images and helpful techniques. $34.95 list, 8.5x11, 128p, 150 color photos, index, order no. 1812.

PROFESSIONAL FILTER TECHNIQUES
FOR DIGITAL PHOTOGRAPHERS

Stan Sholik

Select the best filter options for your photographic style and discover how their use will affect your images. $34.95 list, 8.5x11, 128p, 150 color images, index, order no. 1831.

MASTER'S GUIDE TO WEDDING PHOTOGRAPHY
CAPTURING UNFORGETTABLE MOMENTS AND LASTING IMPRESSIONS

Marcus Bell

Learn to capture the unique energy and mood of each wedding and build a lifelong client relationship. $34.95 list, 8.5x11, 128p, 200 color photos, index, order no. 1832.

DIGITAL CAPTURE AND WORKFLOW
FOR PROFESSIONAL PHOTOGRAPHERS

Tom Lee

Cut your image-processing time by fine-tuning your workflow. Includes tips for working with Photoshop and Adobe Bridge, plus framing, matting, and more. $34.95 list, 8.5x11, 128p, 150 color images, index, order no. 1835.

MASTER GUIDE FOR GLAMOUR PHOTOGRAPHY

Chris Nelson

Establish a rapport with your model, ensure a successful shoot, and master the essential digital fixes your clients demand. Includes lingerie, semi-nude, and nude images. $34.95 list, 8.5x11, 128p, 200 color photos, index, order no. 1836.

THE PHOTOGRAPHER'S GUIDE TO
COLOR MANAGEMENT
PROFESSIONAL TECHNIQUES FOR CONSISTENT RESULTS

Phil Nelson

Learn how to keep color consistent from device to device, ensuring greater efficiency and more accurate results. $34.95 list, 8.5x11, 128p, 175 color photos, index, order no. 1838.

SOFTBOX LIGHTING TECHNIQUES
FOR PROFESSIONAL PHOTOGRAPHERS

Stephen A. Dantzig

One of photography's most popular lighting devices to produce soft, flawless effects for portraits, product shots, and more. $34.95 list, 8.5x11, 128p, 260 color images, index, order no. 1839.

CHILDREN'S PORTRAIT PHOTOGRAPHY HANDBOOK

Bill Hurter

Packed with inside tips from industry leaders, this book shows you the ins and outs of working with some of photography's most challenging subjects. $34.95 list, 8.5x11, 128p, 175 color images, index, order no. 1840.

JEFF SMITH'S **LIGHTING FOR OUTDOOR AND LOCATION PORTRAIT PHOTOGRAPHY**

Learn how to use light throughout the day—indoors and out—and make location portraits a highly profitable venture for your studio. $34.95 list, 8.5x11, 128p, 170 color images, index, order no. 1841.

PROFESSIONAL CHILDREN'S PORTRAIT PHOTOGRAPHY

Lou Jacobs Jr.

Fifteen top photographers reveal their most successful techniques—from working with un-cooperative kids, to lighting, to marketing your studio. $34.95 list, 8.5x11, 128p, 200 color photos, index, order no. 2001.

CHILDREN'S PORTRAIT PHOTOGRAPHY
A PHOTOJOURNALISTIC APPROACH

Kevin Newsome

Learn how to capture spirited images that reflect your young subject's unique personality and developmental stage. $34.95 list, 8.5x11, 128p, 150 color images, index, order no. 1843.

PROFESSIONAL PORTRAIT POSING
TECHNIQUES AND IMAGES FROM MASTER PHOTOGRAPHERS

Michelle Perkins

Learn how master photographers pose subjects to create unforgettable images. $34.95 list, 8.5x11, 128p, 175 color images, index, order no. 2002.

STUDIO PORTRAIT PHOTOGRAPHY OF CHILDREN AND BABIES, 3rd Ed.

Marilyn Sholin

Work with the youngest portrait clients to create cherished images. Includes techniques for working with kids at every developmental stage, from infant to preschooler. $34.95 list, 8.5x11, 128p, 140 color photos, order no. 1845.

MONTE ZUCKER'S
PORTRAIT PHOTOGRAPHY HANDBOOK

Acclaimed portrait photographer Monte Zucker takes you behind the scenes and shows you how to create a "Monte Portrait." Covers techniques for both studio and location shoots. $34.95 list, 8.5x11, 128p, 200 color photos, index, order no. 1846.

DIGITAL PHOTOGRAPHY FOR CHILDREN'S AND FAMILY PORTRAITURE, 2nd Ed.

Kathleen Hawkins

Learn how staying on top of advances in digital photography can boost your sales and improve your artistry and workflow. $34.95 list, 8.5x11, 128p, 195 color images, index, order no. 1847.

LIGHTING AND POSING TECHNIQUES FOR PHOTOGRAPHING WOMEN

Norman Phillips

Make every female client look her very best. This book features tips from top pros and diagrams that will facilitate learning. $34.95 list, 8.5x11, 128p, 200 color images, index, order no. 1848.

LIGHTING TECHNIQUES FOR
LOW KEY PORTRAIT PHOTOGRAPHY

Norman Phillips

Learn to create the dark tones and dramatic lighting that typify this classic portrait style. $34.95 list, 8.5x11, 128p, 100 color photos, index, order no. 1773.

THE BEST OF CHILDREN'S PORTRAIT PHOTOGRAPHY

Bill Hurter

Rangefinder editor Bill Hurter draws upon the experience and work of top professional photographers, uncovering the creative and technical skills they use to create their magical portraits of these young subjects. $29.95 list, 8.5x11, 128p, 150 color photos, order no. 1752.

THE BEST OF PHOTOGRAPHIC LIGHTING
2nd Ed.

Bill Hurter

Top pros reveal the secrets behind their studio, location, and outdoor lighting strategies. Packed with tips for portraits, still lifes, and more. $34.95 list, 8.5x11, 128p, 200 color photos, index, order no. 1849.

MASTER GUIDE FOR TEAM SPORTS PHOTOGRAPHY

James Williams

Learn how adding team sports photography to your repertoire can help you meet your financial goals. Includes technical, artistic, organizational, and business strategies. $34.95 list, 8.5x11, 128p, 120 color photos, index, order no. 1850.

JEFF SMITH'S POSING TECHNIQUES FOR LOCATION PORTRAIT PHOTOGRAPHY

Use architectural and natural elements to support the pose, maximize the flow of the session, and create refined, artful poses for individual subjects and groups—indoors or out. $34.95 list, 8.5x11, 128p, 150 color photos, index, order no. 1851.

MASTER LIGHTING GUIDE
FOR WEDDING PHOTOGRAPHERS

Bill Hurter

Capture perfect lighting quickly and easily at the ceremony and reception—indoors and out. Includes tips from the pros for lighting individuals, couples, and groups. $34.95 list, 8.5x11, 128p, 200 color photos, index, order no. 1852.

THE BEST OF PORTRAIT PHOTOGRAPHY

2nd Ed.

Bill Hurter

View outstanding images from top pros and learn how they create their masterful classic and contemporary portraits. $34.95 list, 8.5x11, 128p, 180 color photos, index, order no. 1854.

WEDDING AND PORTRAIT PHOTOGRAPHERS' LEGAL HANDBOOK

N. Phillips and C. Nudo, Esq.

Don't leave yourself exposed! Sample forms and practical discussions help you protect yourself and your business. $29.95 list, 8.5x11, 128p, 25 sample forms, index, order no. 1796.

PROFITABLE PORTRAITS
THE PHOTOGRAPHER'S GUIDE TO CREATING PORTRAITS THAT SELL

Jeff Smith

Learn how to design images that are precisely tailored to your clients' tastes—portraits that will practically sell themselves! $29.95 list, 8.5x11, 128p, 100 color photos, index, order no. 1797.

THE ART OF PREGNANCY PHOTOGRAPHY

Jennifer George

Learn the essential posing, lighting, composition, business, and marketing skills you need to create stunning pregnancy portraits your clientele can't do without! $34.95 list, 8.5x11, 128p, 150 color photos, index, order no. 1855.

BIG BUCKS SELLING YOUR PHOTOGRAPHY, 4th Ed.

Cliff Hollenbeck

Build a new business or revitalize an existing one with the comprehensive tips in this popular book. Includes twenty forms you can use for invoicing clients, collections, follow-ups, and more. $34.95 list, 8.5x11, 144p, resources, business forms, order no. 1856.

PHOTOGRAPHING CHILDREN WITH SPECIAL NEEDS

Karen Dórame

This book explains the symptoms of spina bifida, autism, cerebral palsy, and more, teaching photographers how to safely and effectively work with clients to capture the unique personalities of these children. $29.95 list, 8.5x11, 128p, 100 color photos, order no. 1749.

ILLUSTRATED DICTIONARY OF PHOTOGRAPHY

Barbara A. Lynch-Johnt & Michelle Perkins

Gain insight into camera and lighting equipment, accessories, technological advances, film and historic processes, famous photographers, artistic movements, and more with the concise descriptions in this illustrated book. $34.95 list, 8.5x11,